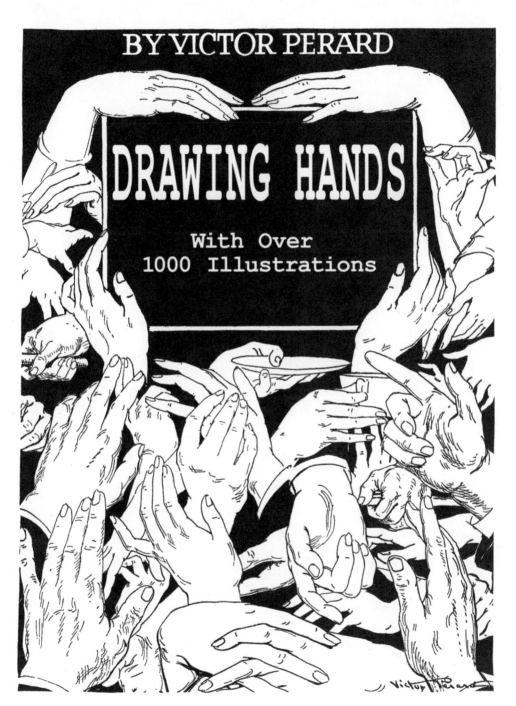

BY VICTOR PERARD

DRAWING HANDS

With Over 1000 Illustrations

DOVER PUBLICATIONS, INC.
Mineola, New York

Bibliographical Note

This Dover edition, first published in 2012, is an unabridged republication of the work originally published by Victor Perard, New York, in 1940 under the title *Hands and Their Construction*.

Library of Congress Cataloging-in-Publication Data

Perard, Victor Semon, 1870-1957.
 Drawing hands : with over 1000 illustrations / Victor Perard.
 p. cm.
 "This Dover edition, first published in 2012, is an unabridged republication of the work originally published by Victor Perard, New York, in 1940 under the title Hands and Their Construction."
 ISBN-13: 978-0-486-48916-2
 ISBN-10: 0-486-48916-7
 1. Hand in art. 2. Drawing—Technique. I. Title.

NC774.P4 2012
743.4'9—dc23

 2012001546

Manufactured in the United States by Courier Corporation
48916702
www.doverpublications.com

This book is dedicated to the many earnest
students whom it has been my privilege
to guide.

I like to draw Napoleon best
Because one hand is in his vest,
The other hand behind his back.
(For drawing hands I have no knack.)

OLIVER HERFORD

FOREWORD

The illustrations in this book, numbering more than a thousand, are intended as an aid to the figure artist in the drawing of hands by giving him a better understanding of their structure, character and expression.

In order to draw a hand correctly the artist must have a knowledge of its internal structure, of the bones that make up its framework and define its proportions, of the muscles that direct its actions. Therefore the anatomy of the hand has been emphasized with notes on proportions which the student would do well to memorize and test from nature. The grouping of hands is intended to impress upon him the modifications of their form as they are seen from various angles.

The senses of sight, smell and hearing are, in general, much keener in animals than in man. Man, however, excels in the sense of touch. Since it is through this sense that the recognition and appreciation of smoothness, roughness, size, texture, heat and cold, are transmitted to the brain, man's superiority in this sense has been an important factor in his greater mental development.

To a great extent the civilization of man has depended upon the fact that his thumb is so constructed that it can oppose his fingers. This position of the thumb has enabled him to use his hands in various ways which have had an important bearing on the advance of his

development. The thumb of the monkey's hand is not as flexible as that of man; it is set too far back to oppose his fingers easily. This accounts for the slowness in his evolution as compared with that of man even though, in the matter of time, he may have had the advantage.

At the finger tips are those minute spiral ridges of cuticle, the prints of which are used for identification. Corresponding to these ridges are depressions, on the inner surface of the cuticle, which give lodgment to the soft pulpy matter in which terminate the nerves that transmit the sense of touch. The cushions and padding of gristle on the finger tips protect their delicate blood vessels, when, as in the act of grasping firmly, injury might result from arrested circulation. Moreover the nails, being broad and shield-like, support the finger tips and protect their elastic cushions.

From the point of view of the artist, more important even than its transmission to the brain of external impressions, is the part which the hand plays in expressing the emotional states of the mind.

It is hoped that, from this series of drawings, the student may note how such emotions as anger, resignation, serenity, surprise, fear, are made manifest by the hand. If he does, he will realize that, in the characterization of a figure, the drawing of the hand plays a part which is second in importance only to that of the face.

CONTENTS

GROUP I
ANATOMY *of* the HAND

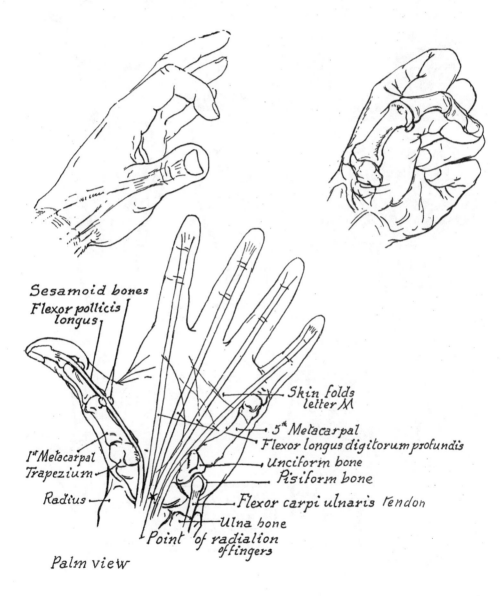

Sesamoid bones
Flexor pollicis
longus

Skin folds
letter M

5ᵗʰ Metacarpal
Flexor longus digitorum profundis
Unciform bone
Pisiform bone

1ˢᵗ Metacarpal
Trapezium

Flexor carpi ulnaris tendon

Radius

Ulna bone

Point of radiation
of fingers

Palm view

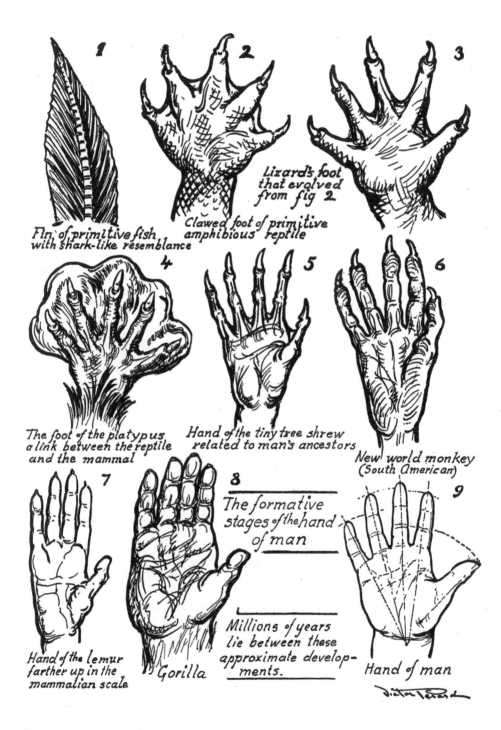

1

Fin of primitive fish
with shark-like resemblance

2

Clawed foot of primitive
amphibious reptile

3

Lizard's foot
that evolved
from fig 2

4

The foot of the platypus
a link between the reptile
and the mammal

5

Hand of the tiny tree shrew
related to man's ancestors

6

New world monkey
(South American)

7

Hand of the lemur
farther up in the
mammalian scale

8

Gorilla

The formative
stages of the hand
of man

Millions of years
lie between these
approximate develop-
ments.

9

Hand of man

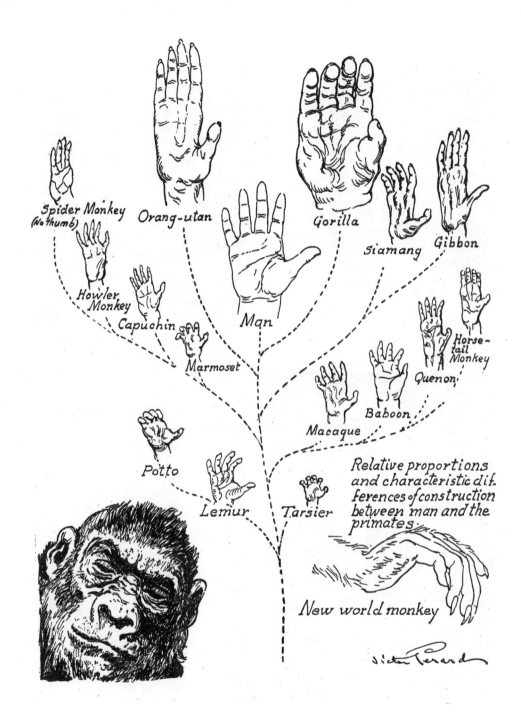

Spider Monkey (No thumb)

Orang-utan

Gorilla

Siamang

Gibbon

Howler Monkey

Capuchin

Man

Horse-tail Monkey

Marmoset

Quenon

Baboon

Macaque

Potto

Lemur

Tarsier

Relative proportions and characteristic differences of construction between man and the primates.

New world monkey

3

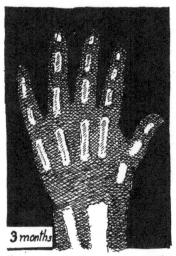

Drawn from X ray negatives illustrating the formative stages of the skeleton of the hands of children

3 months

Bones appear as cartilaginous skeleton, which is gradually replaced by bone.

Victor Perard

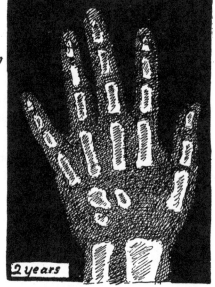

2 years

2 years of age The rate and manner of ossification differ somewhat in the sexes, girls being slightly in advance of boys.

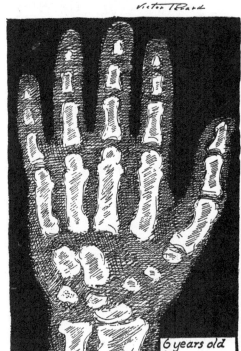

6 years old JP

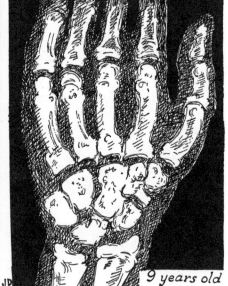

9 years old

4

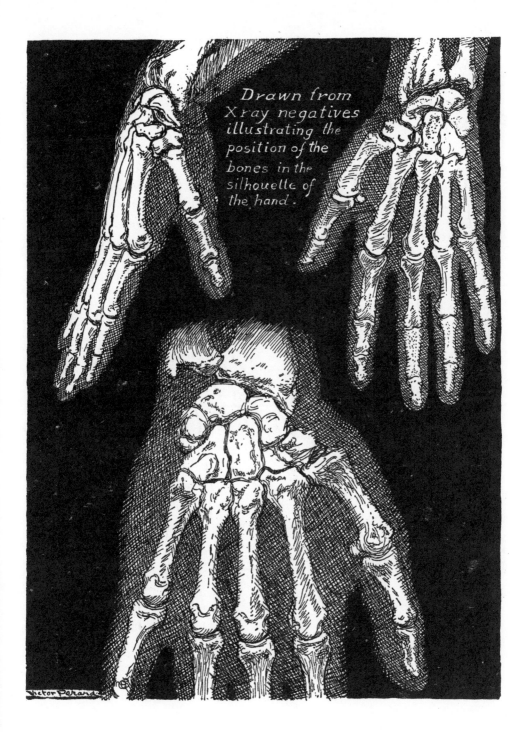

Drawn from
Xray negatives
illustrating the
position of the
bones in the
silhouette of
the hand.

Victor Perard

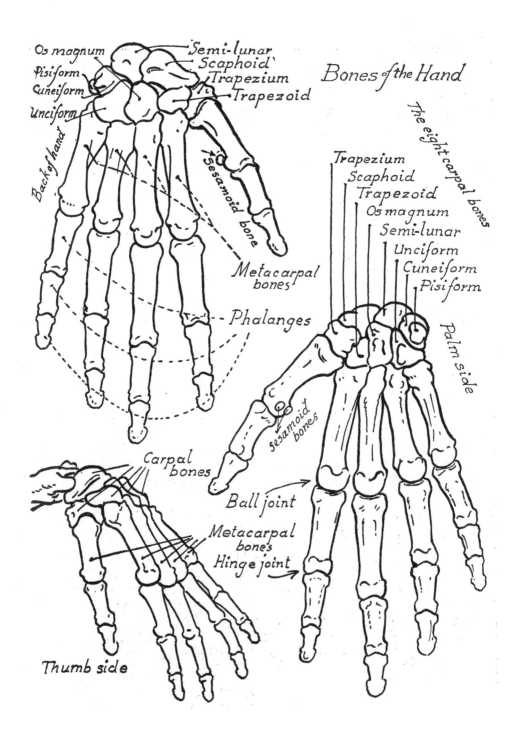

Os magnum
Pisiform
Cuneiform
Unciform

Semi-lunar
Scaphoid
Trapezium
Trapezoid

Bones of the Hand

The eight carpal bones

Back of hand

Sesamoid bone

Metacarpal bones

Phalanges

Trapezium
Scaphoid
Trapezoid
Os magnum
Semi-lunar
Unciform
Cuneiform
Pisiform

Palm side

Sesamoid bones

Ball joint

Carpal bones

Metacarpal bones

Hinge joint

Thumb side

Phalanges

Metacarpal bone ←

Ball joint ←

Placement of skin folds in relation
to joints on index finger.

The first phalanx equals in length the second and third together

3rd 2nd 1st Metacarpal bone

Placement of skin folds in relation to joints (middle finger)

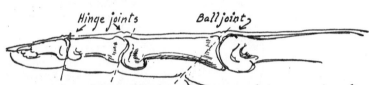

Hinge joints Ball joint

Placement of skin folds in relation to joints on ring finger

The pads are equal in length
on each finger.

Placement of skin folds in relation to joints on little finger

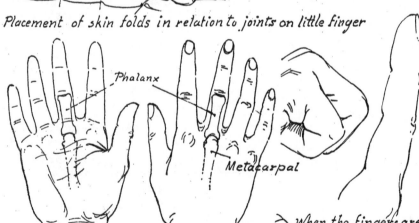

Phalanx

Metacarpal

The fingers appear shorter on the palm
side than on the dorsal side of the hand.
This is due to the webb between the
fingers which reaches midway on the
phalanges.

When the fingers are fully
bent you have four folds
instead of three as when the
fingers are straight.

7

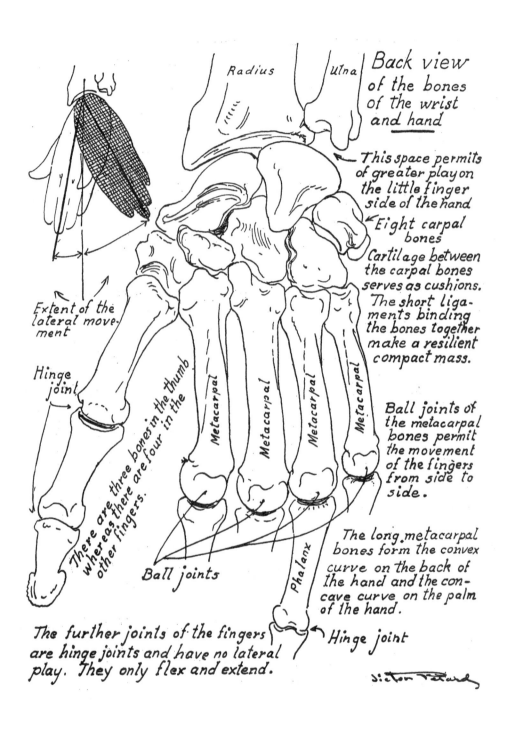

Radius

Ulna

Back view
of the bones
of the wrist
and hand

This space permits
of greater play on
the little finger
side of the hand

Eight carpal
bones

Cartilage between
the carpal bones
serves as cushions.
The short liga-
ments binding
the bones together
make a resilient
compact mass.

Extent of the
lateral move-
ment

Hinge
joint

There are three bones in the thumb
whereas there are four in the
other fingers.

Metacarpal

Metacarpal

Metacarpal

Metacarpal

Ball joints of
the metacarpal
bones permit
the movement
of the fingers
from side to
side.

Ball joints

Phalanx

The long metacarpal
bones form the convex
curve on the back of
the hand and the con-
cave curve on the palm
of the hand.

The further joints of the fingers
are hinge joints and have no lateral
play. They only flex and extend.

Hinge joint

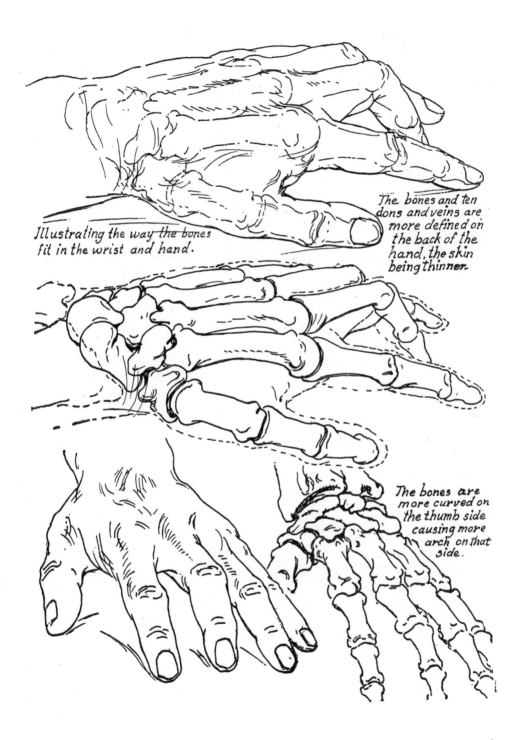

Illustrating the way the bones
fit in the wrist and hand.

The bones and ten
dons and veins are
more defined on
the back of the
hand, the skin
being thinner.

The bones are
more curved on
the thumb side
causing more
arch on that
side.

9

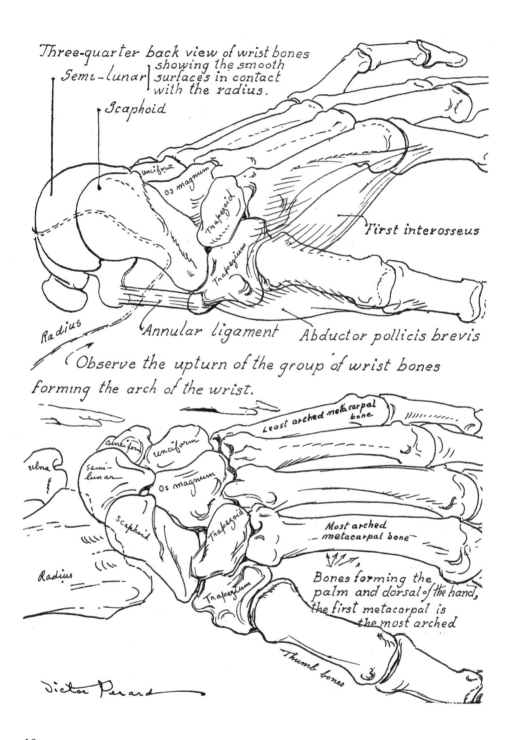

Three-quarter back view of wrist bones
showing the smooth surfaces in contact
with the radius.

Semi-lunar

Scaphoid

unciform

Os magnum

Trapezoid

Trapezium

First interosseus

Radius

Annular ligament

Abductor pollicis brevis

Observe the upturn of the group of wrist bones
forming the arch of the wrist.

Least arched metacarpal bone

cuneiform

unciform

ulna

Semi-lunar

Os magnum

Scaphoid

Trapezoid

Radius

Trapezium

Most arched metacarpal bone

Bones forming the
palm and dorsal of the hand,
the first metacarpal is
the most arched

Thumb bones

Victor Perard

10

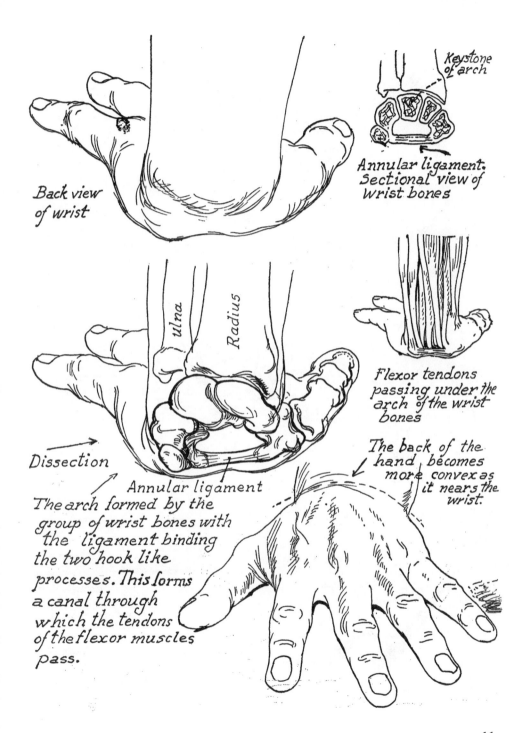

Back view
of wrist

Keystone
of arch

Annular ligament.
Sectional view of
wrist bones

ulna

Radius

Dissection

Annular ligament

The arch formed by the
group of wrist bones with
the ligament binding
the two hook like
processes. This forms
a canal through
which the tendons
of the flexor muscles
pass.

Flexor tendons
passing under the
arch of the wrist
bones

The back of the
hand becomes
more convex as
it nears the
wrist.

11

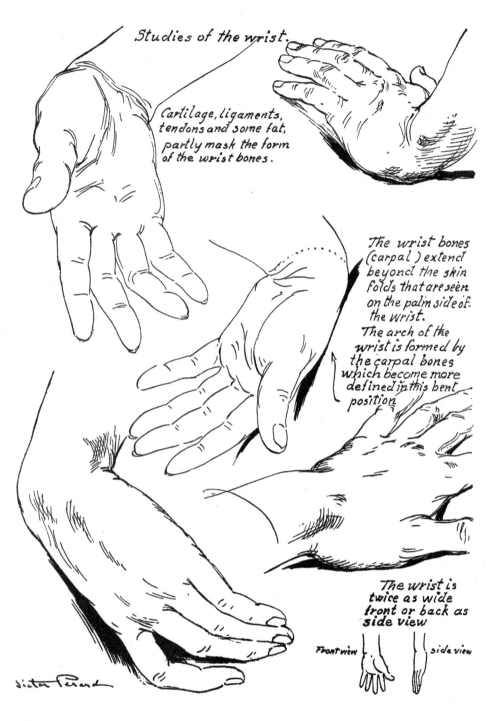

Studies of the wrist.

Cartilage, ligaments, tendons and some fat, partly mask the form of the wrist bones.

The wrist bones (carpal) extend beyond the skin folds that are seen on the palm side of the wrist.

The arch of the wrist is formed by the carpal bones which become more defined in this bent position

The wrist is twice as wide front or back as side view

Front view side view

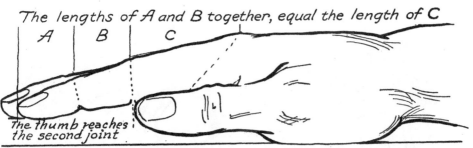

The lengths of A and B together, equal the length of C

A B C

The thumb reaches the second joint

When the hand is resting on a flat surface, the wrist does not come in contact with that surface.

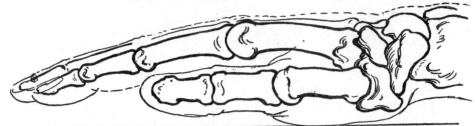

The wrist bones are grouped far into the wrist forming the arch of the wrist.

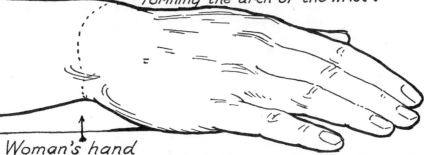

Woman's hand

Relative positions of the bones from the little finger side when the hand is resting on a flat surface.

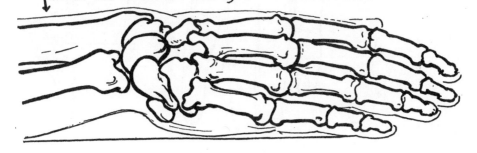

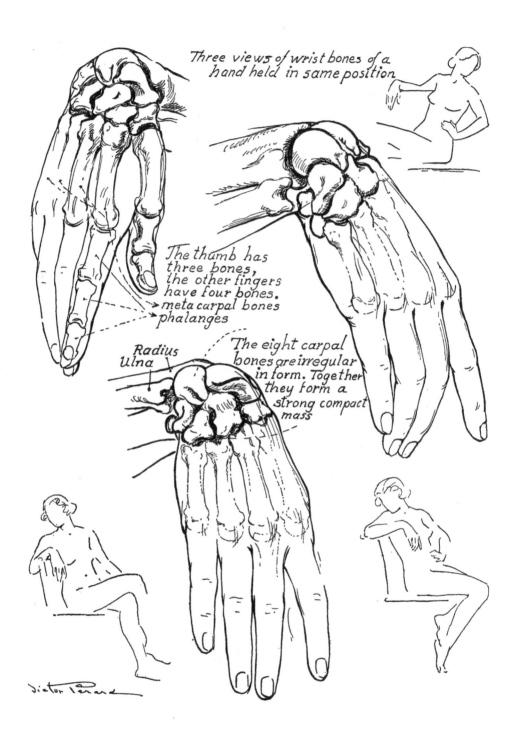

Three views of wrist bones of a hand held in same position

The thumb has three bones, the other fingers have four bones.
→ meta carpal bones
→ phalanges

Radius
Ulna

The eight carpal bones are irregular in form. Together they form a strong compact mass

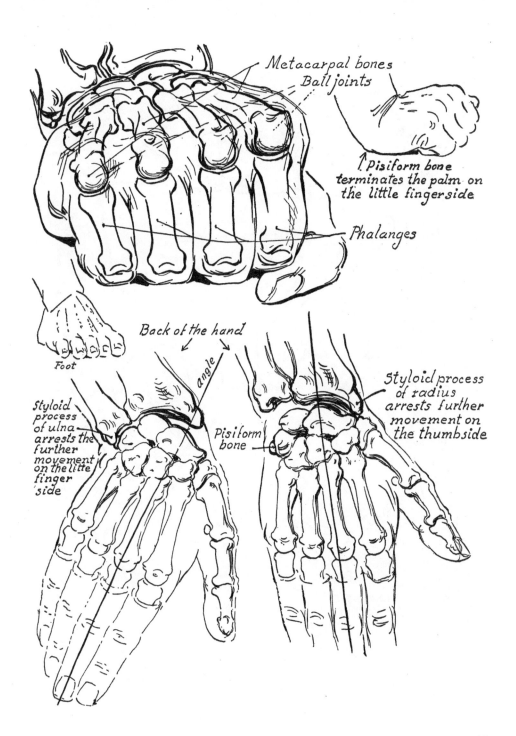

Metacarpal bones
Ball joints

Pisiform bone
terminates the palm on
the little finger side

Phalanges

Back of the hand

angle

Foot

Styloid
process
of ulna
arrests the
further
movement
on the little
finger
side

Pisiform
bone

Styloid process
of radius
arrests further
movement on
the thumbside

15

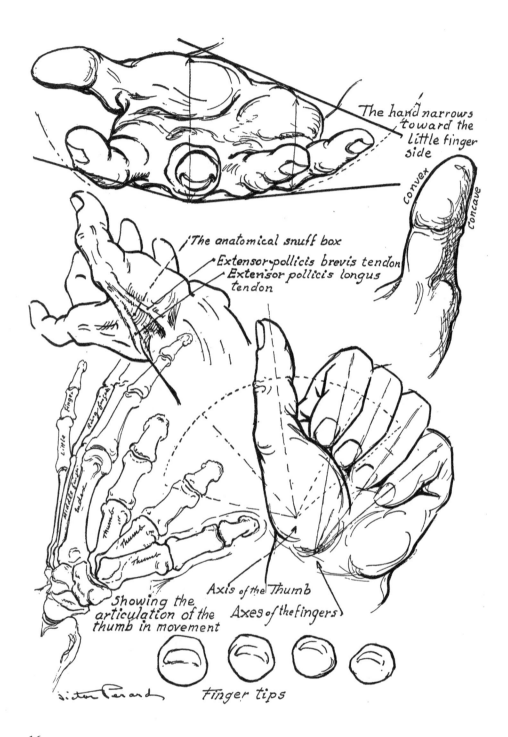

The hand narrows toward the little finger side

convex concave

The anatomical snuff box
Extensor pollicis brevis tendon
Extensor pollicis longus tendon

Little Finger
Ring Finger
Middle Finger
Index
Thumb
Thumb
Thumb
Thumb

Showing the articulation of the thumb in movement

Axis of the Thumb
Axes of the fingers

Finger tips

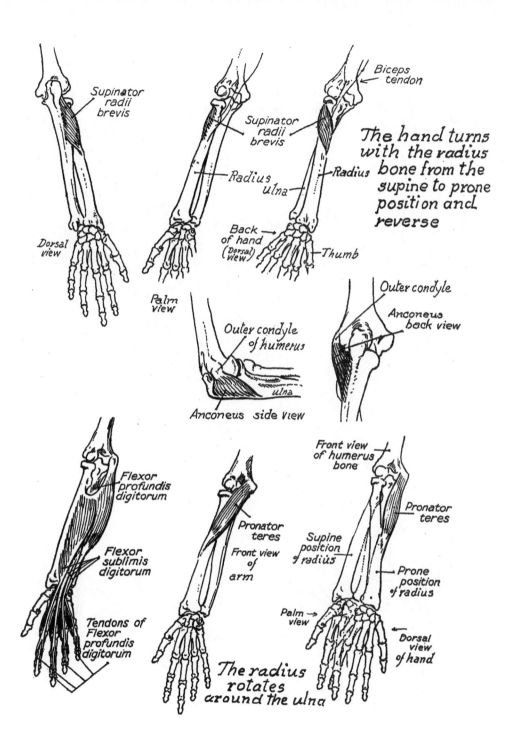

Supinator radii brevis

Dorsal view

Supinator radii brevis

Radius
Ulna

Palm view

Biceps tendon

Radius

Back of hand (Dorsal view)

Thumb

The hand turns with the radius bone from the supine to prone position and reverse

Outer condyle of humerus

Anconeus side view

ulna

Outer condyle

Anconeus back view

Flexor profundis digitorum

Flexor sublimis digitorum

Tendons of Flexor profundis digitorum

Pronator teres

Front view of arm

Front view of humerus bone

Supine position of radius

Palm → view

The radius rotates around the ulna

Pronator teres

Prone position of radius

Dorsal view of hand

17

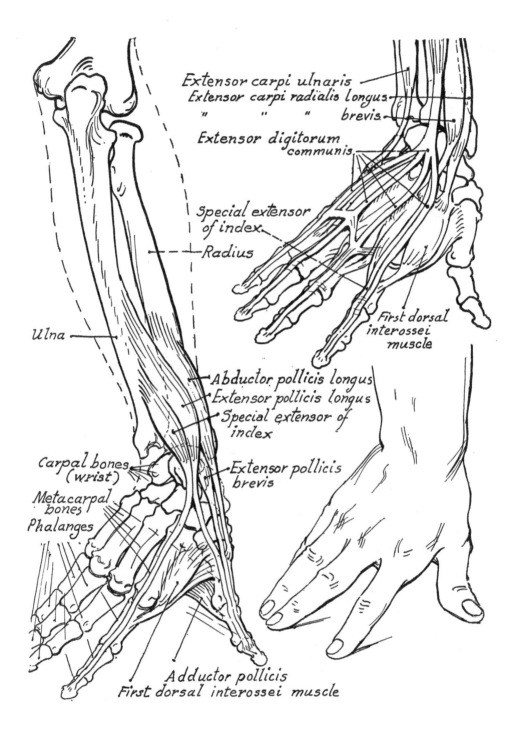

Extensor carpi ulnaris
Extensor carpi radialis longus
" " " brevis

Extensor digitorum
communis

Special extensor
of index

Radius

Ulna

First dorsal
interossei
muscle

Abductor pollicis longus
Extensor pollicis longus
Special extensor of
index

Carpal bones
(wrist)

Extensor pollicis
brevis

Metacarpal
bones
Phalanges

Adductor pollicis
First dorsal interossei muscle

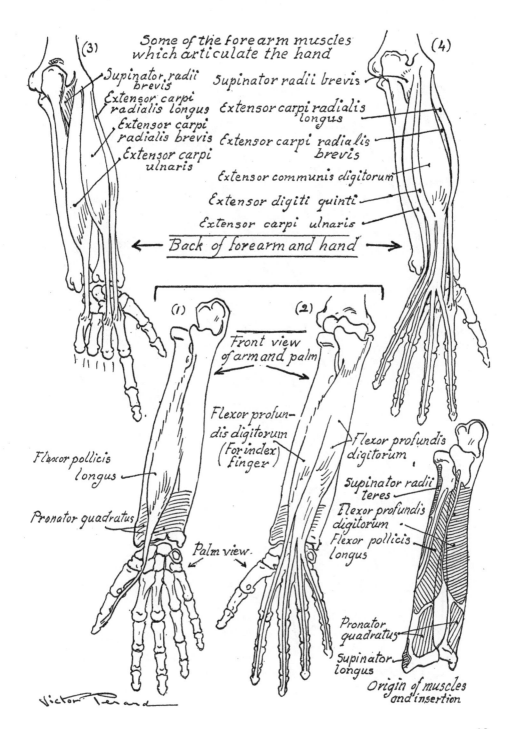

Some of the forearm muscles
which articulate the hand

(3)

(4)

Supinator radii brevis

Supinator radii brevis

Extensor carpi radialis longus

Extensor carpi radialis longus

Extensor carpi radialis brevis

Extensor carpi radialis brevis

Extensor carpi ulnaris

Extensor communis digitorum

Extensor digiti quinti

Extensor carpi ulnaris

← Back of forearm and hand →

(1)

(2)

Front view of arm and palm

Flexor profundis digitorum (For index) finger)

Flexor profundis digitorum

Flexor pollicis longus

Supinator radii teres

Pronator quadratus

Flexor profundis digitorum

Flexor pollicis longus

Palm view

Pronator quadratus

Supinator longus

Victor Perard

Origin of muscles and insertion

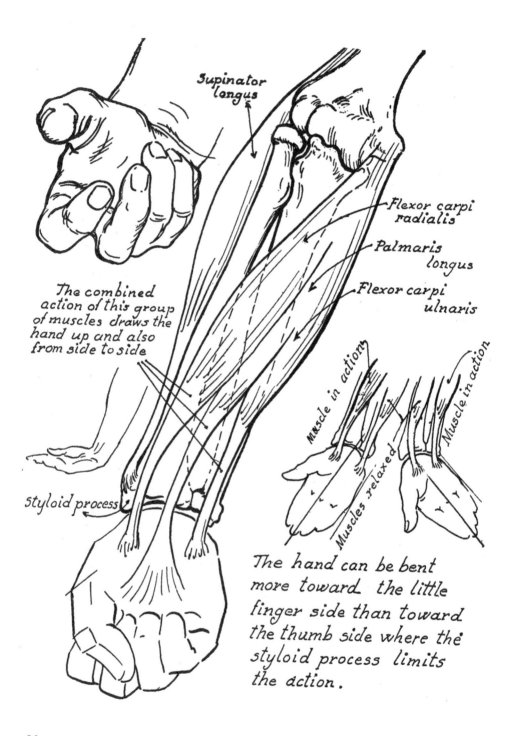

Supinator
longus

Flexor carpi
radialis

Palmaris
longus

Flexor carpi
ulnaris

The combined
action of this group
of muscles draws the
hand up and also
from side to side

Muscle in action

Muscle in action

Muscles relaxed

styloid process

The hand can be bent
more toward the little
finger side than toward
the thumb side where the
styloid process limits
the action.

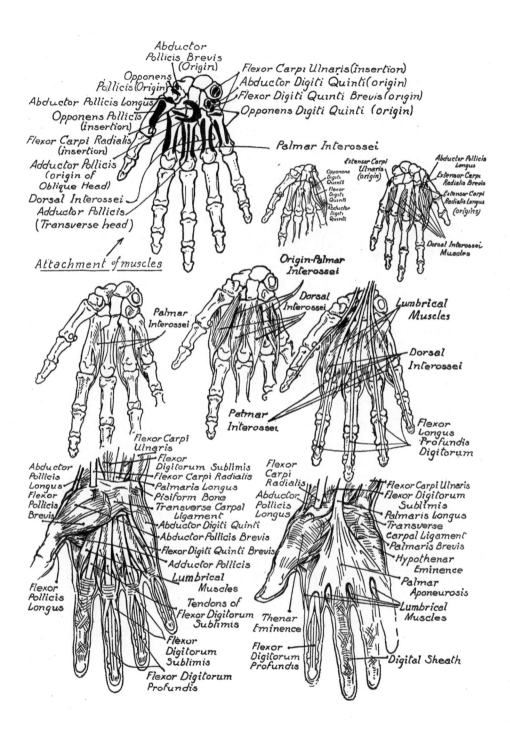

Abductor
Pollicis Brevis
(Origin)

Opponens
Pollicis (Origin)

Abductor Pollicis Longus

Opponens Pollicis
(insertion)

Flexor Carpi Radialis
(insertion)

Adductor Pollicis
(origin of
Oblique Head)

Dorsal Interossei

Adductor Pollicis
(Transverse head)

Flexor Carpi Ulnaris (insertion)
Abductor Digiti Quinti (origin)
Flexor Digiti Quinti Brevis (origin)
Opponens Digiti Quinti (origin)

Palmer Interossei

Attachment of muscles

Origin-Palmar
Interossei

Palmar
Interossei

Extensor Carpi
Ulnaris
(origin)

Opponens
Digiti
Quinti

Flexor
Digiti
Quinti

Abductor
Digiti
Quinti

Abductor Pollicis
Longus

Extensor Carpi
Radialis Brevis

Extensor Carpi
Radialis Longus
(origins)

Dorsal Interossei
Muscles

Dorsal
Interossei

Lumbrical
Muscles

Dorsal
Interossei

Palmar
Interossei

Flexor
Longus
Profundis
Digitorum

Flexor Carpi
Ulnaris

Abductor
Pollicis
Longus
Flexor
Pollicis
Brevis

Flexor
Pollicis
Longus

Flexor
Digitorum Sublimis
Flexor Carpi Radialis
Palmaris Longus
Pisiform Bone
Transverse Carpal
Ligament
Abductor Digiti Quinti
Abductor Pollicis Brevis
Flexor Digiti Quinti Brevis
Adductor Pollicis
Lumbrical
Muscles
Tendons of
Flexor Digitorum
Sublimis
Flexor
Digitorum
Sublimis
Flexor Digitorum
Profundis

Flexor
Carpi
Radialis

Abductor
Pollicis
Longus

Thenar
Eminence

Flexor
Digitorum
Profundis

Flexor Carpi Ulnaris
Flexor Digitorum
Sublimis
Palmaris Longus
Transverse
Carpal Ligament
Palmaris Brevis
Hypothenar
Eminence
Palmar
Aponeurosis
Lumbrical
Muscles

Digital Sheath

21

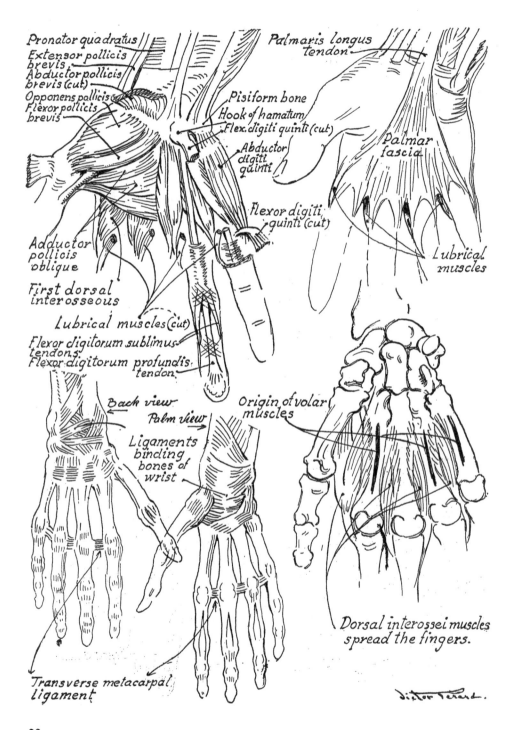

Pronator quadratus
Extensor pollicis brevis
Abductor pollicis brevis (cut)
Opponens pollicis
Flexor pollicis brevis
Palmaris longus tendon
Pisiform bone
Hook of hamatum
Flex. digiti quinti (cut)
Abductor digiti quinti
Palmar fascia
Adductor pollicis oblique
First dorsal interosseous
Flexor digiti quinti (cut)
Lubrical muscles (cut)
Flexor digitorum sublimus tendons
Flexor digitorum profundis tendon
Lubrical muscles
Back view
Palm view
Origin of volar muscles
Ligaments binding bones of wrist
Transverse metacarpal ligament
Dorsal interossei muscles spread the fingers.

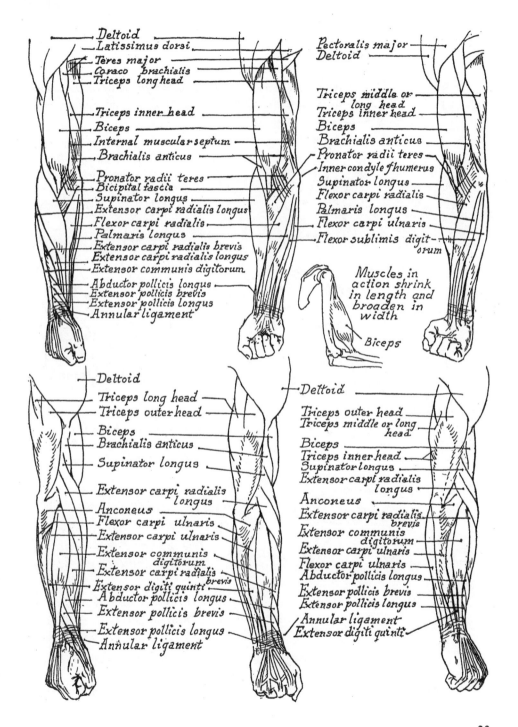

Deltoid
Latissimus dorsi
Teres major
Coraco brachialis
Triceps long head

Triceps inner head
Biceps
Internal muscular septum
Brachialis anticus

Pronator radii teres
Bicipital fascia
Supinator longus
Extensor carpi radialis longus
Flexor carpi radialis
Palmaris longus
Extensor carpi radialis brevis
Extensor carpi radialis longus
Extensor communis digitorum

Abductor pollicis longus
Extensor pollicis brevis
Extensor pollicis longus
Annular ligament

Pectoralis major
Deltoid

Triceps middle or
long head
Triceps inner head
Biceps
Brachialis anticus
Pronator radii teres
Inner condyle of humerus
Supinator longus
Flexor carpi radialis
Palmaris longus
Flexor carpi ulnaris
Flexor sublimis digit-
orum

Muscles in
action shrink
in length and
broaden in
width

Biceps

Deltoid
Triceps long head
Triceps outer head

Biceps
Brachialis anticus

Supinator longus

Extensor carpi radialis
longus
Anconeus
Flexor carpi ulnaris
Extensor carpi ulnaris

Extensor communis
digitorum
Extensor carpi radialis
brevis
Extensor digiti quinti
Abductor pollicis longus

Extensor pollicis brevis

Extensor pollicis longus
Annular ligament

Deltoid

Triceps outer head
Triceps middle or long
head
Biceps
Triceps inner head
Supinator longus
Extensor carpi radialis
longus
Anconeus
Extensor carpi radialis
brevis
Extensor communis
digitorum
Extensor carpi ulnaris
Flexor carpi ulnaris
Abductor pollicis longus
Extensor pollicis brevis
Extensor pollicis longus
Annular ligament
Extensor digiti quinti

23

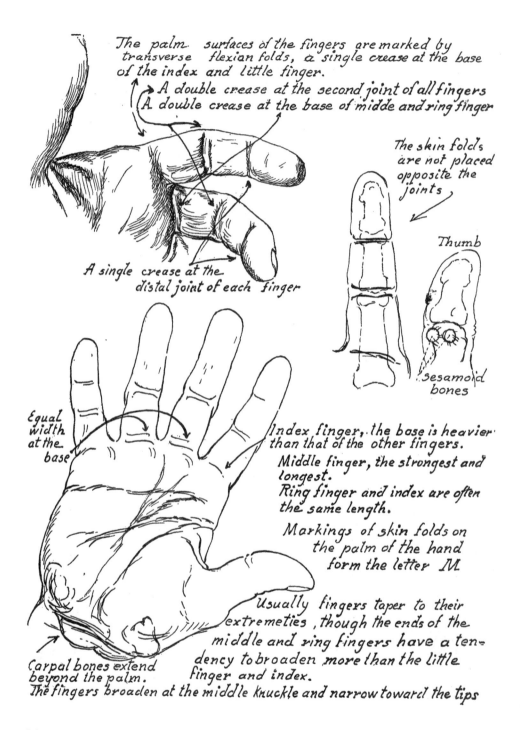

The palm surfaces of the fingers are marked by transverse flexian folds, a single crease at the base of the index and little finger.

A double crease at the second joint of all fingers
A double crease at the base of midde and ring finger

The skin folds are not placed opposite the joints

A single crease at the distal joint of each finger

Thumb

Sesamoid bones

Equal width at the base

Index finger, the base is heavier than that of the other fingers.

Middle finger, the strongest and longest.

Ring finger and index are often the same length.

Markings of skin folds on the palm of the hand form the letter M

Usually fingers taper to their extremeties, though the ends of the middle and ring fingers have a tendency to broaden more than the little finger and index.

Carpal bones extend beyond the palm.
The fingers broaden at the middle knuckle and narrow toward the tips

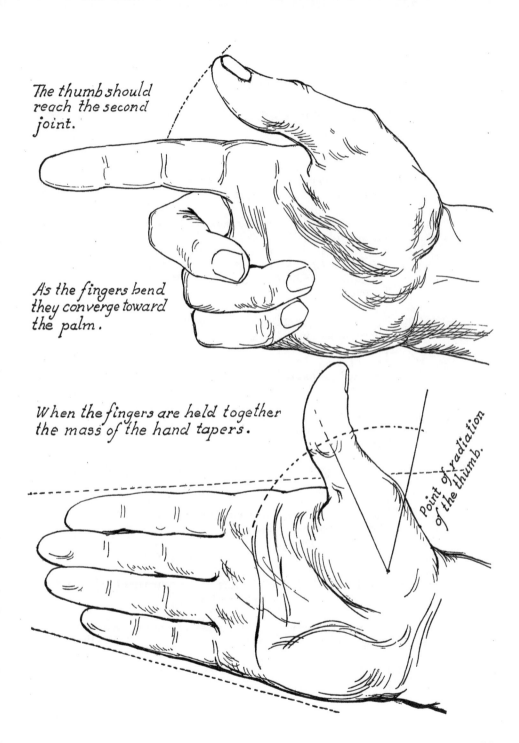

The thumb should reach the second joint.

As the fingers bend they converge toward the palm.

When the fingers are held together the mass of the hand tapers.

Point of radiation of the thumb.

COMPENDIUM

MUSCLES OF THE FOREARM AND HAND

Muscle	Origin	Insertion	Action
Flexor carpi radialis	internal condyle of humerus	base of second metacarpal	flexes wrist
Palmaris longus	internal condyle of humerus	palmar fascia	flexes wrist
Flexor carpi ulnaris	internal condyle of humerus and olecranon of ulna	base of fifth metacarpal	flexes wrist
Flexor sublimis digitorum	internal condyle of humerus and inner side of coronoid process of ulna. Also oblique line of radius	second phalanges	flexes second joints of fingers
Flexor digitorum profundis	shaft of ulna and interosseous membrane	last phalanges	flexes finger tips
Flexor longus pollicis	shaft of radius	last phalanx of thumb	flexes last phalanx of thumb
Pronator teres	internal condyle of humerus and coronoid process of ulna	outer surface of radius	pronates hand (rotates it so that palm is turned down)
Pronator quadratus	lower part of ulna	lower part of radius (outer border)	pronates hand
Supinator longus	external condyloid ridge of humerus	styloid process of radius	supinates hand (rotates it so that palm is turned up) and flexes elbow

COMPENDIUM

MUSCLES OF THE FOREARM AND HAND—Continued

Muscle	Origin	Insertion	Action
Extensor carpi radialis longus	external condyloid ridge of humerus	base of second metacarpal (index finger)	extends wrist
Extensor carpi radialis brevis	external condyloid ridge of humerus	base of third metacarpal (middle finger)	extends wrist
Extensor communis digitorum	external condyle of humerus	last phalanges (four fingers)	extends fingers
Extensor digiti quinti	external condyle of humerus and posterior border of ulna	phalanx of little finger	extends little finger independently
Extensor carpi ulnaris	external condyle of humerus	under side of base of fifth metacarpal	extends hand toward ulnar side
Anconeus	back of external condyle of humerus	olecranon and posterior part of ulna	extends forearm
Supinator brevis	external condyle of humerus, back of ulna	upper part and back of radius	supinates hand
Extensor pollicis longus	back of ulna	base of first plalanx of thumb	extends thumb
Abductor pollicis longus	back of radius and ulna	base of metacarpal of thumb	extends thumb away from palm
Extensor pollicis brevis	back of ulna and interosseous membrane	base of second phalanx of thumb	extends thumb
Extensor of index	back of ulna	second and third phalanges of index	extends index finger independently

27

COMPENDIUM

SHORT MUSCLES OF THE HAND

Muscle	Origin	Insertion	Action
Abductor pollicis brevis	trapezium	first phalanx of thumb	draws thumb away from hand
Opponens pollicis	trapezium	metacarpal of thumb	flexes metacarpal of thumb
Flexor pollicis brevis	trapezium, os magnum, third metacarpal	first phalanx of thumb	flexes thumb
Abductor pollicis longus and oblique head	third metacarpal bone of middle finger	first phalanx of the thumb	draws thumb toward palm
Palmaris brevis	annular ligament and palmar fascia	skin of palm	wrinkles skin
Abductor digiti quinti	pisiform bone	first phalanx of little finger	draws little finger away from the rest
Flexor brevis digiti quinti	unciform bone	first phalanx of little finger	flexes little finger
Opponens digiti quinti	unciform bone	phalanx of little finger	flexes and draws little finger toward the palm
Lumbricals (four)	tendons of deep flexor	back of phalanges	flex first phalanges
Dorsal interossei (four)	sides of metacarpal bones	back of phalanges	draw fingers away from middle line of middle finger
Palmar interossei (three)	palmar surface of metacarpals	side of phalanges	draw fingers toward middle line of middle finger

GROUP 2
METHOD of DRAWING HANDS

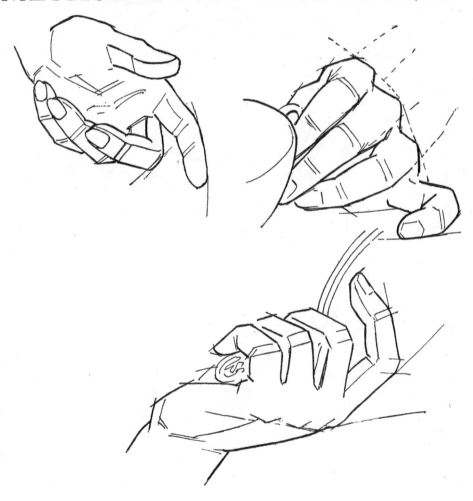

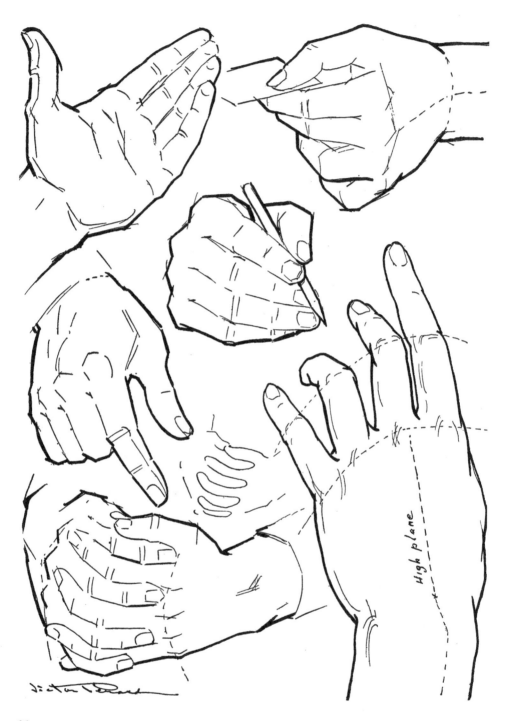

High plane

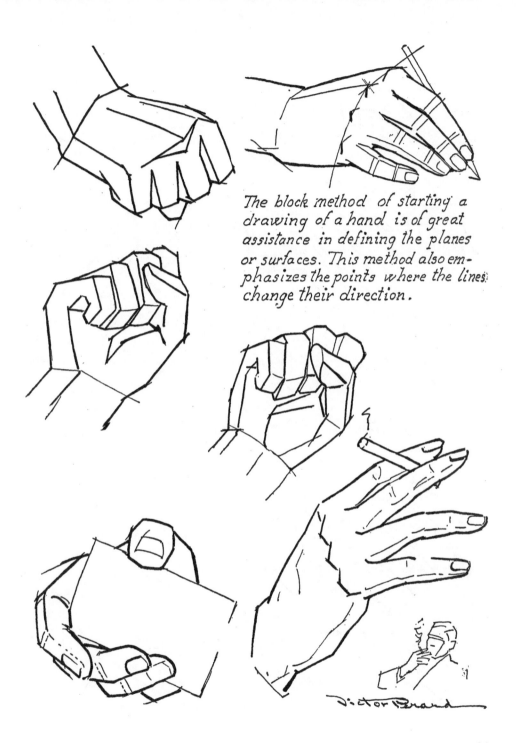

The block method of starting a drawing of a hand is of great assistance in defining the planes or surfaces. This method also emphasizes the points where the lines change their direction.

Victor Perard

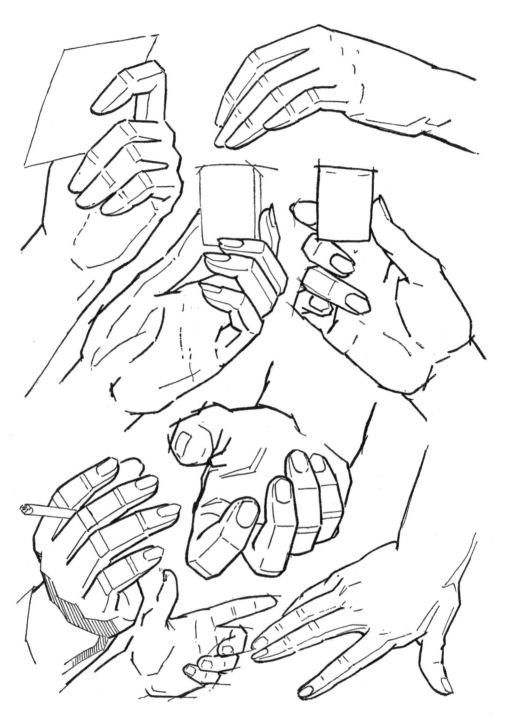

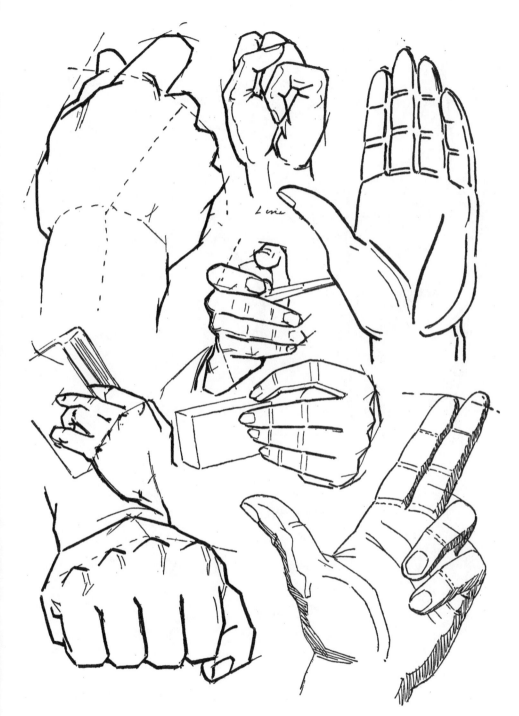

33

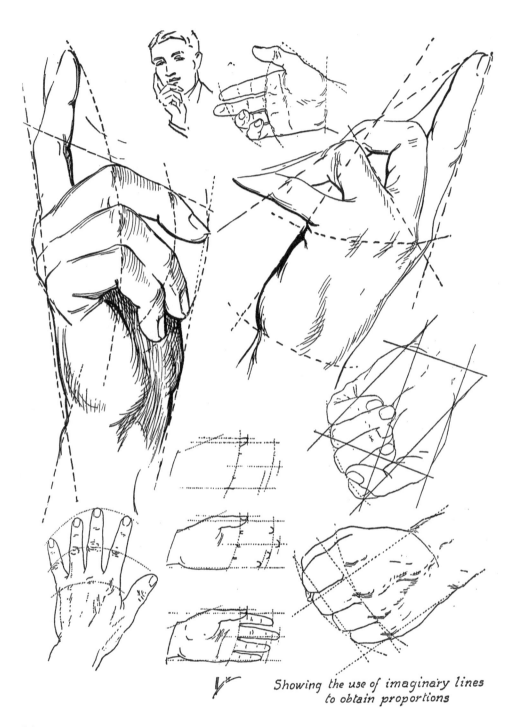

Showing the use of imaginary lines
to obtain proportions

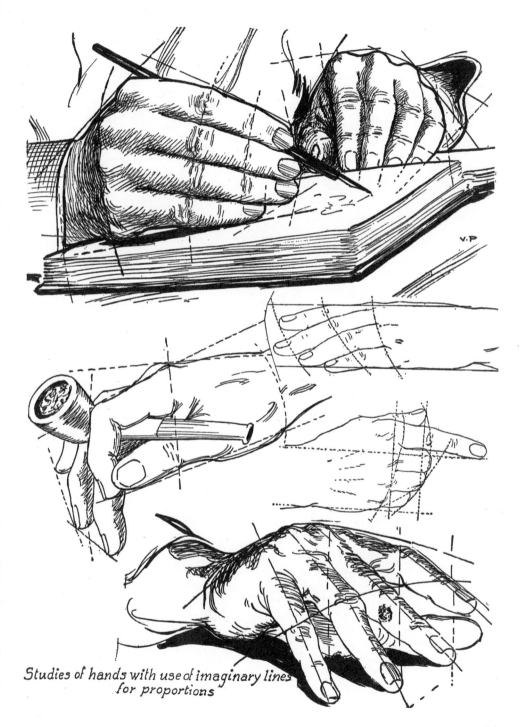

Studies of hands with use of imaginary lines for proportions

GROUP 3
WOMEN'S HANDS in BUSINESS
and SOCIAL ACTIVITIES

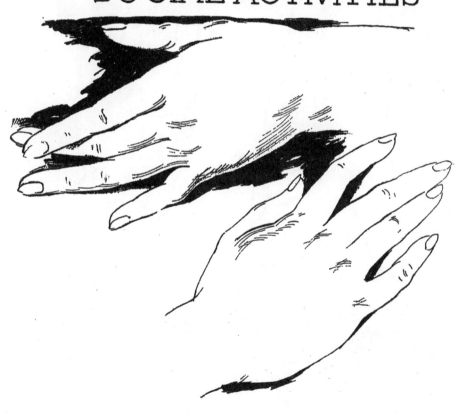

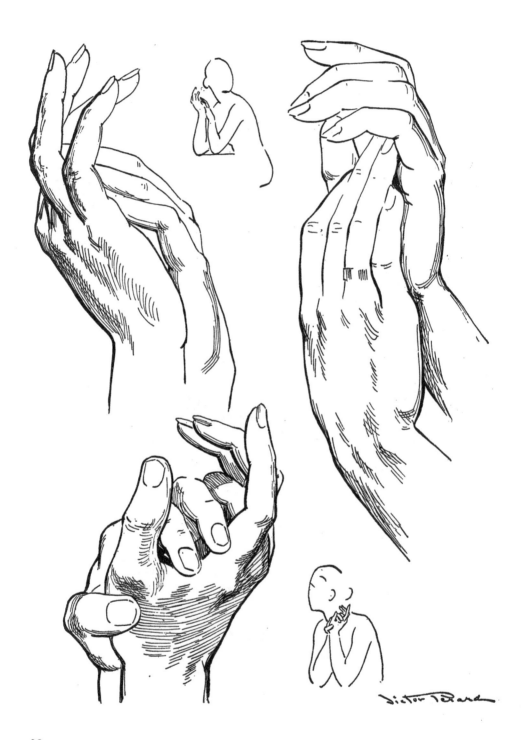

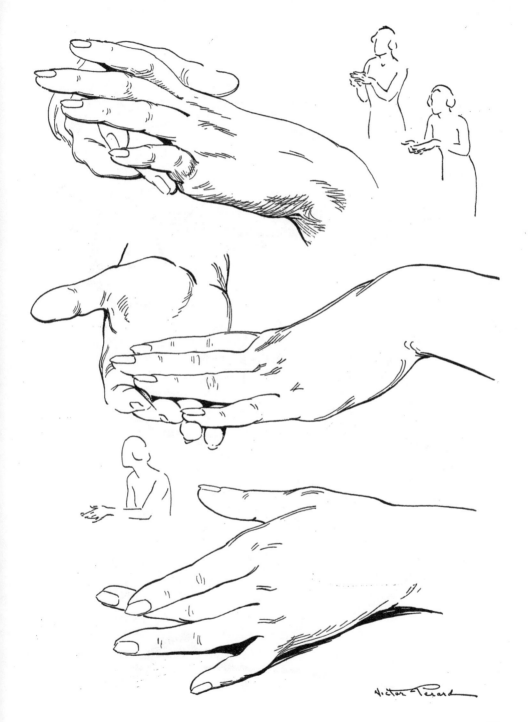

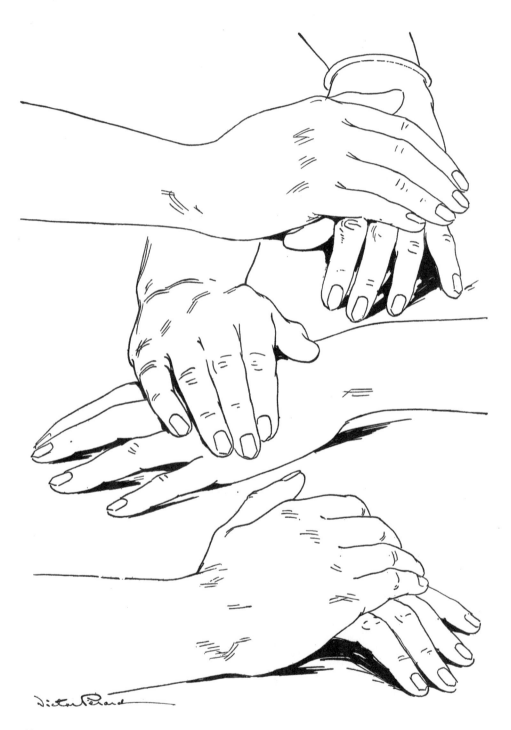

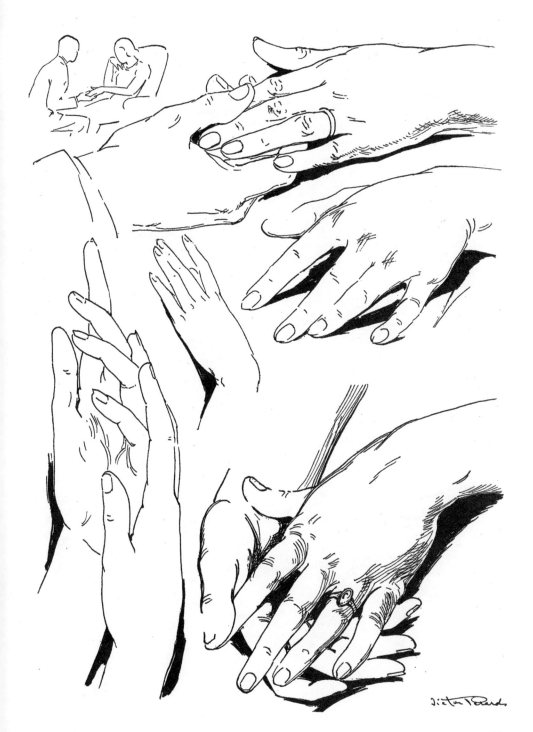

41

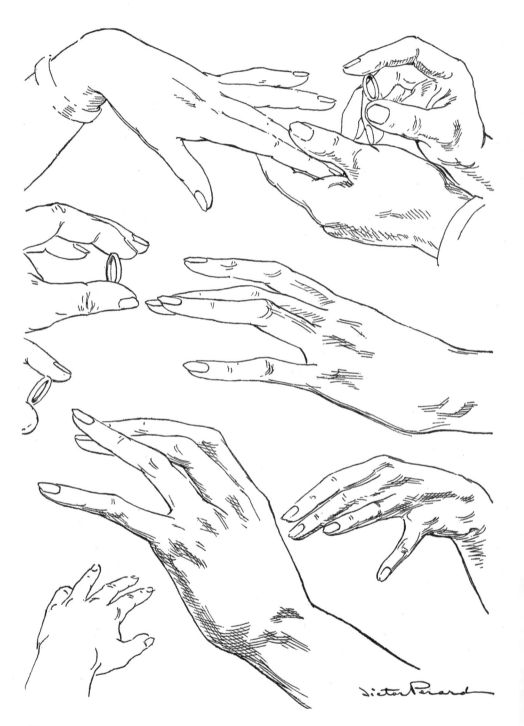

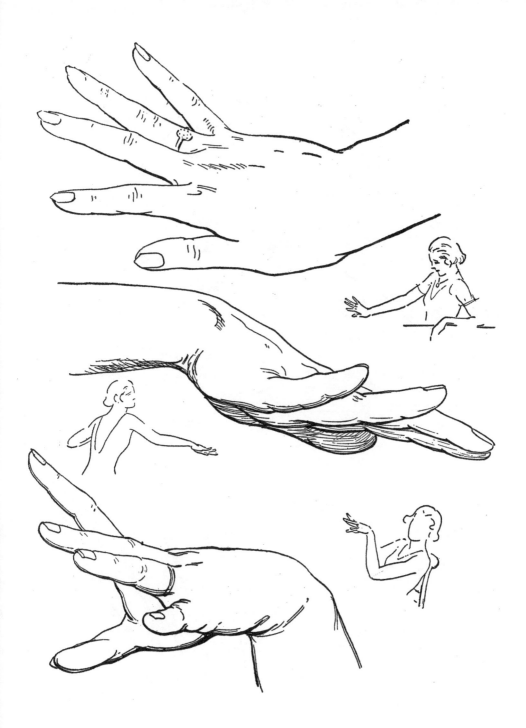

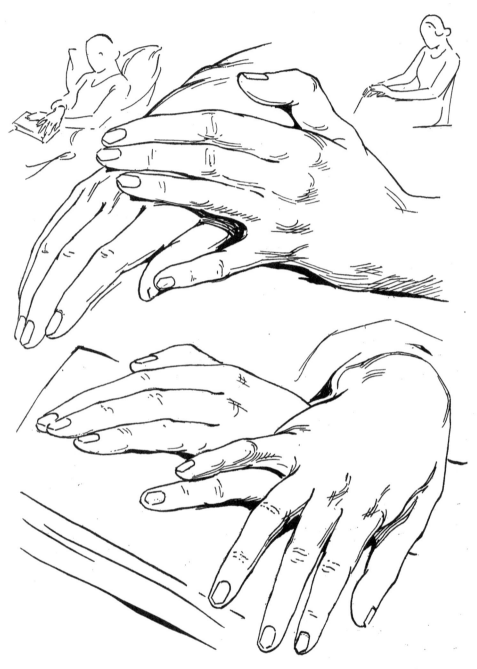

Victor Perard

44

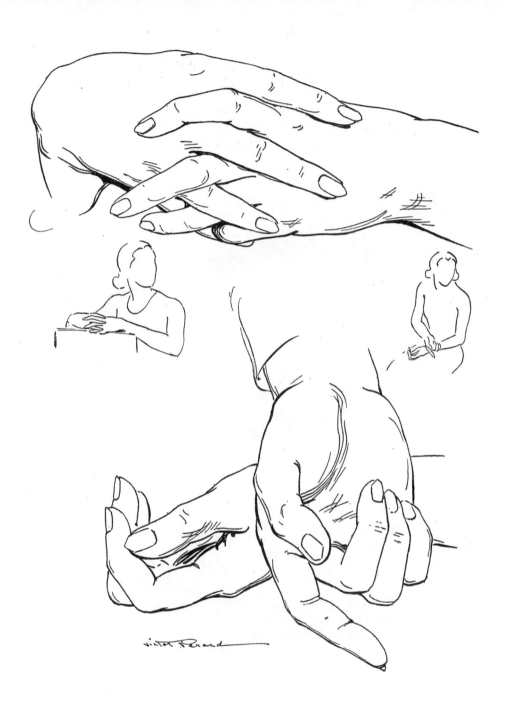

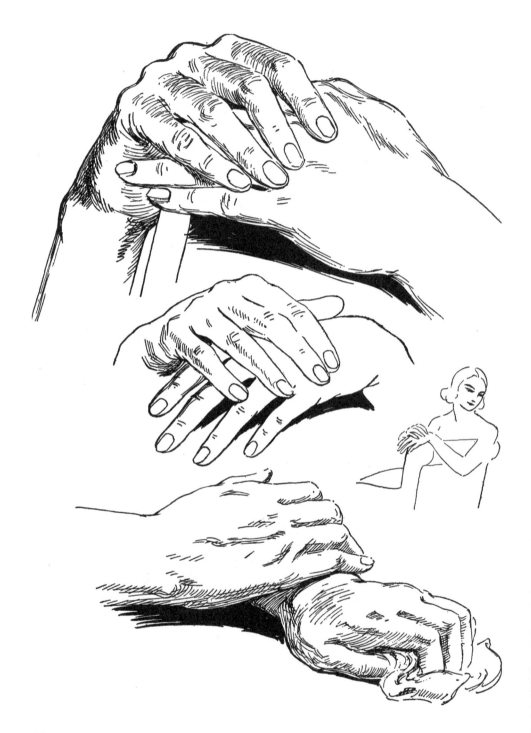

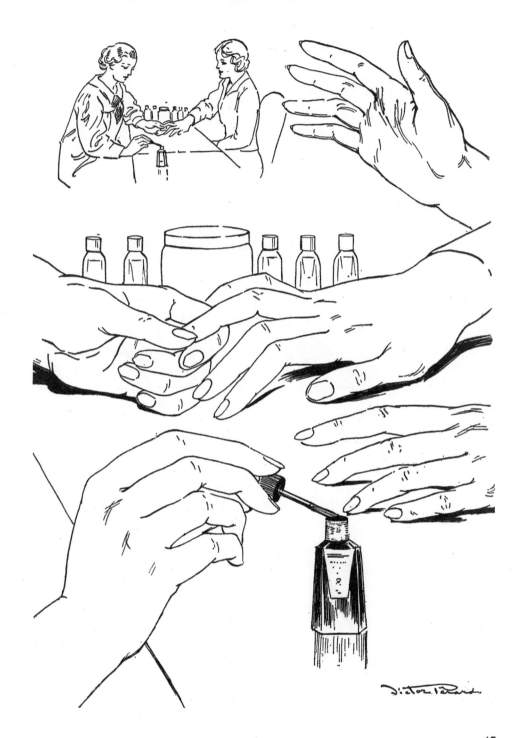

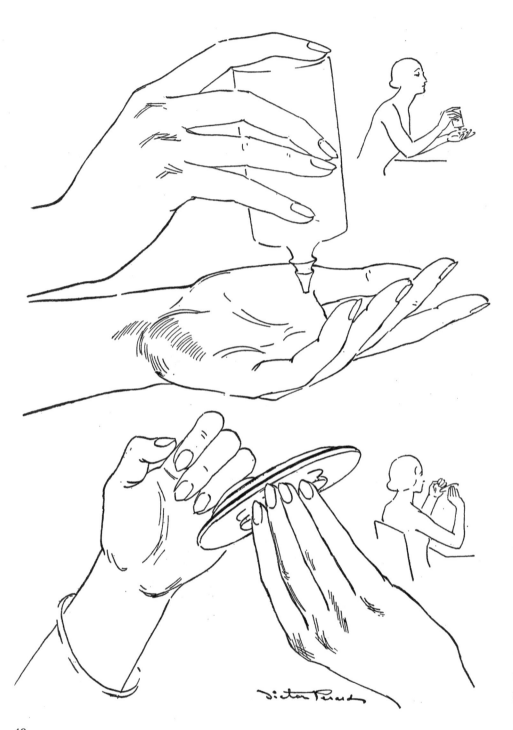

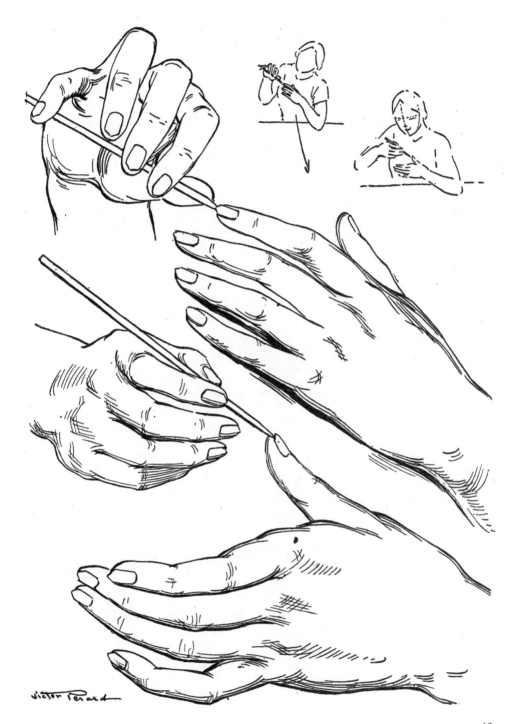

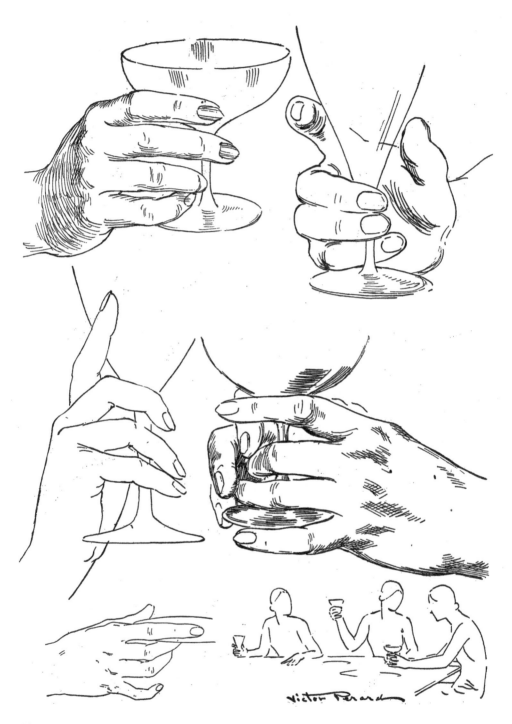

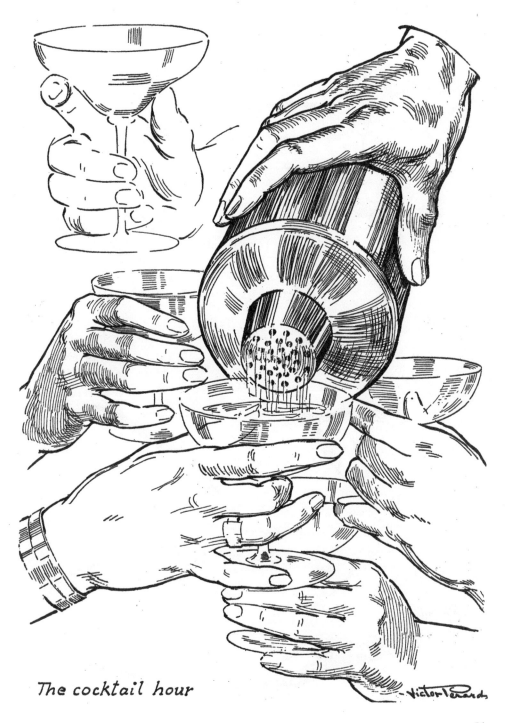

The cocktail hour

Victor Perard

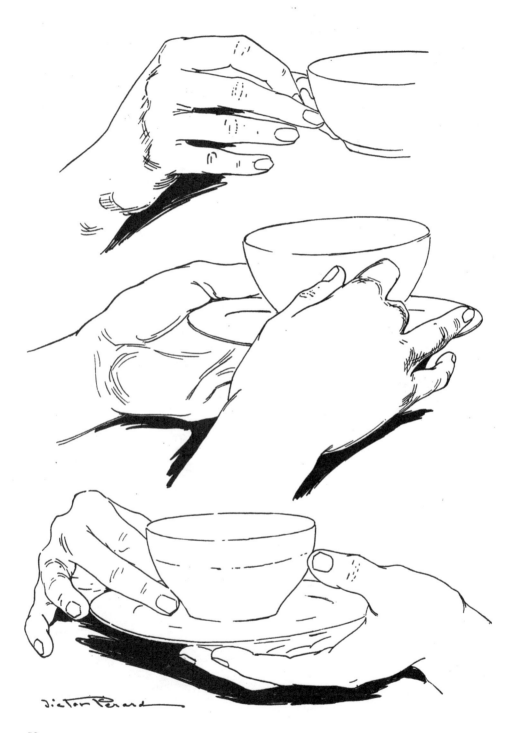

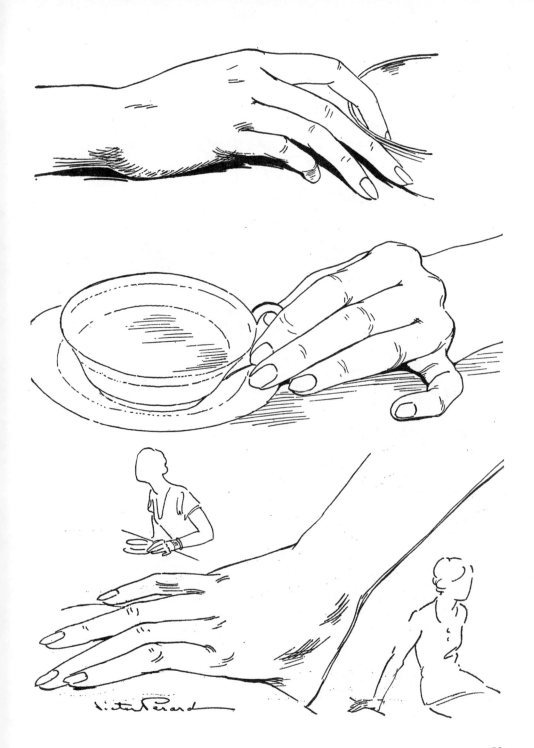

53

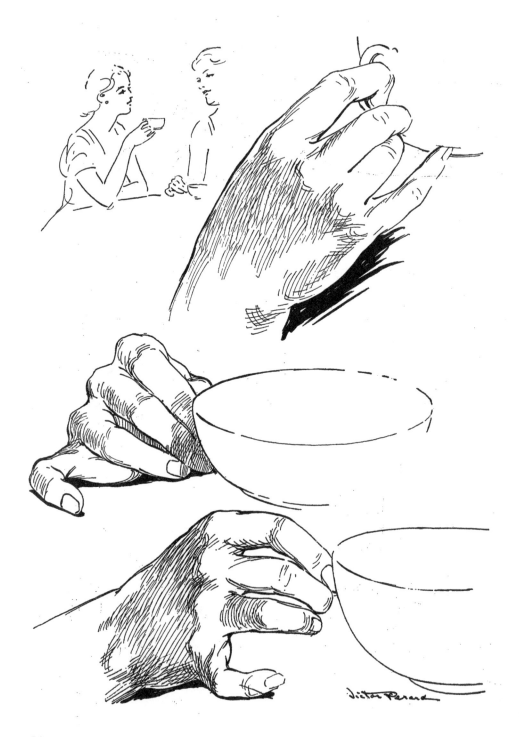

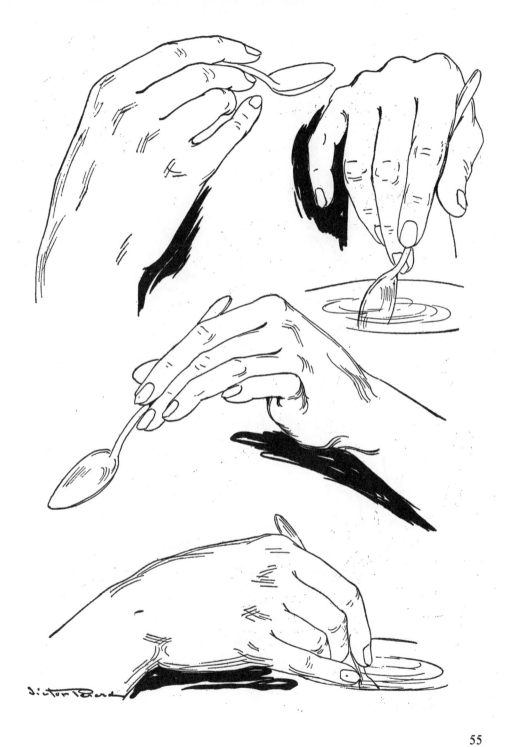

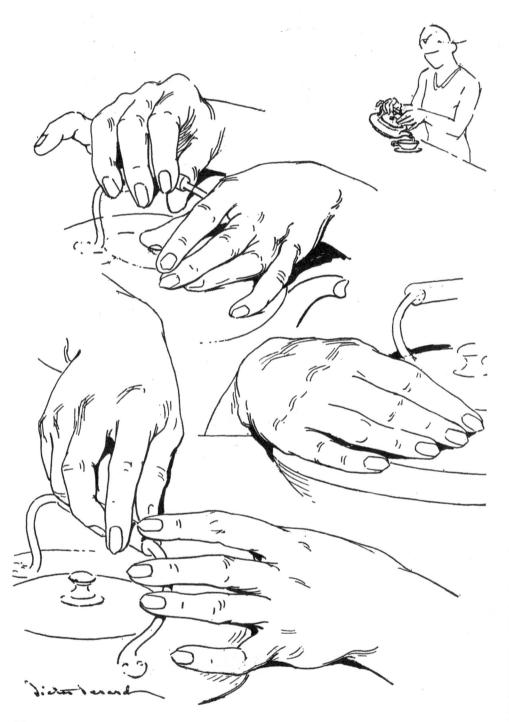

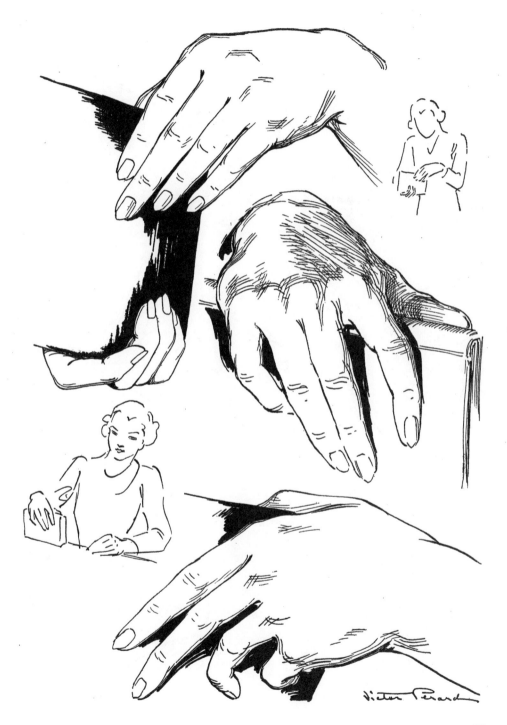

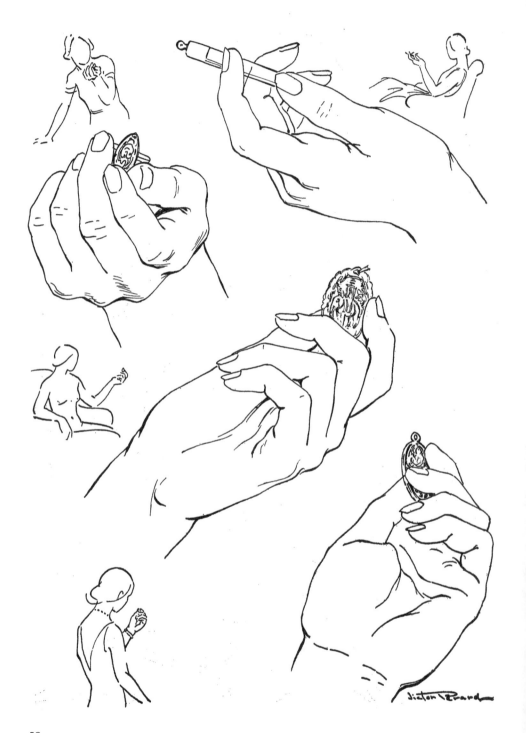

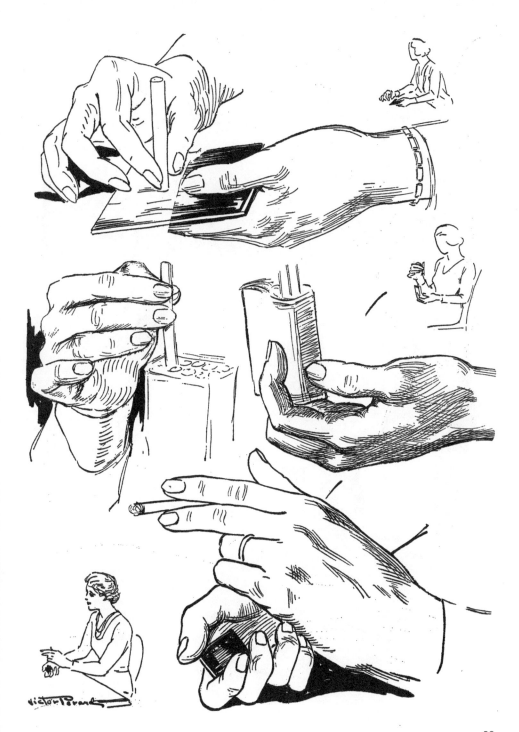

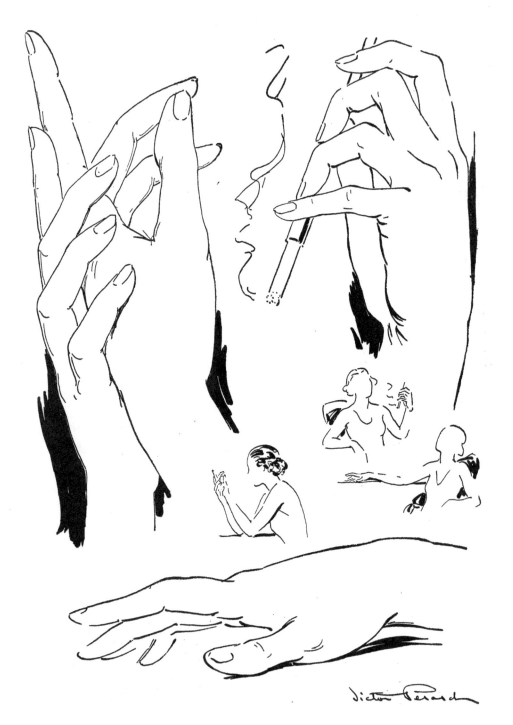

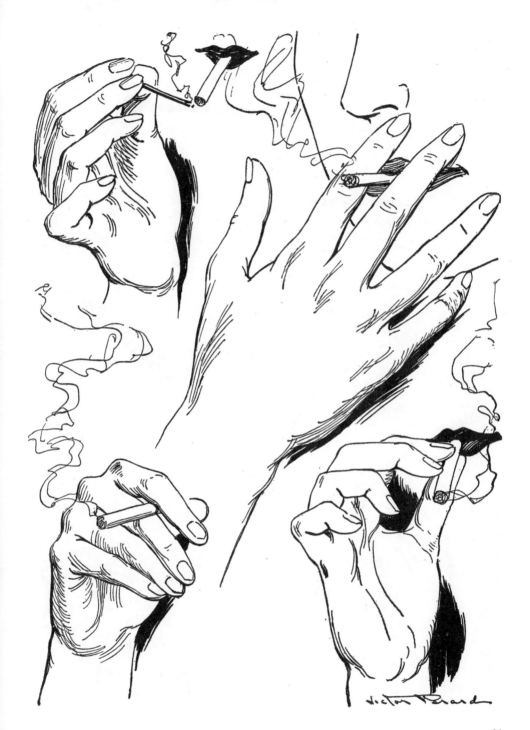

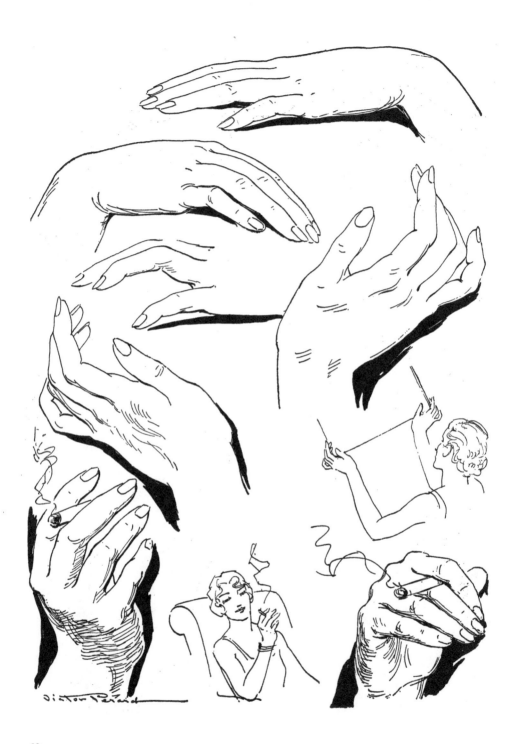

62

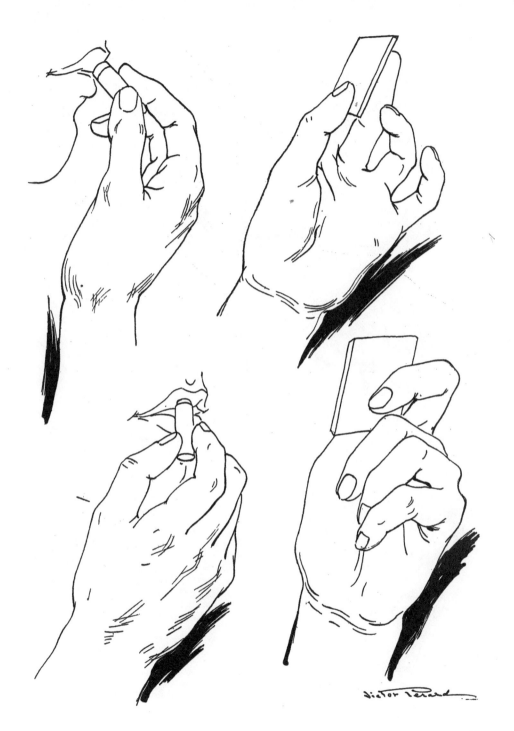

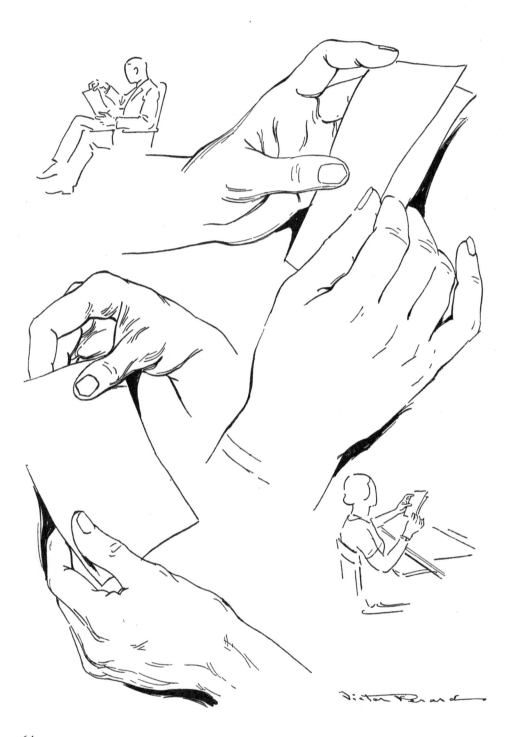

64

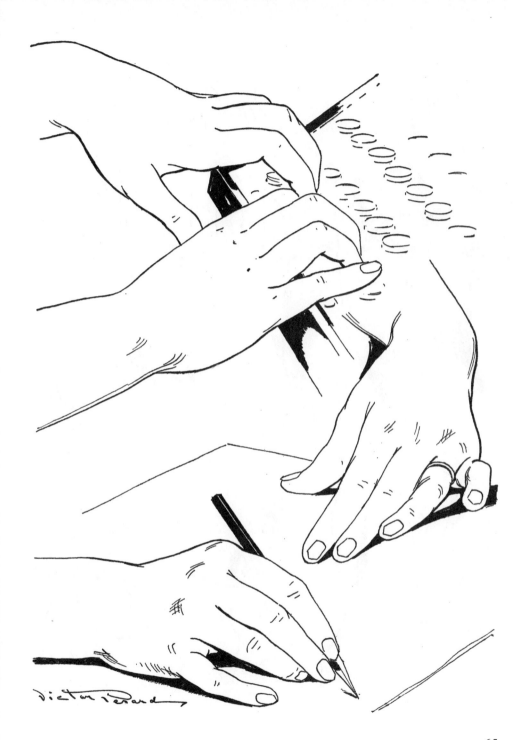

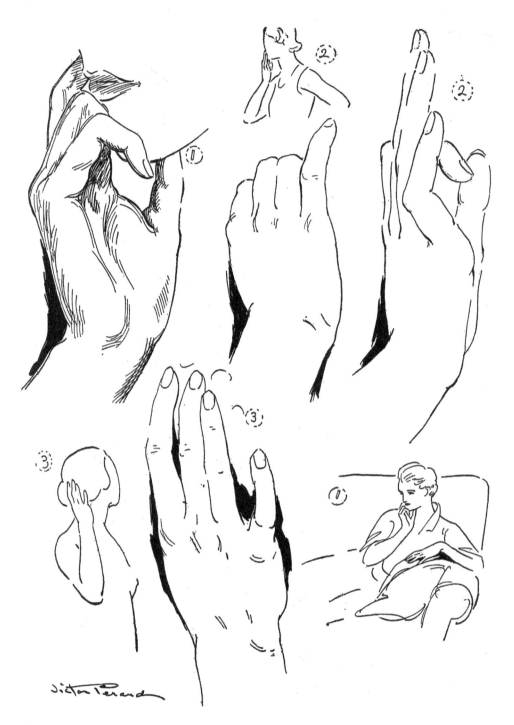

Victor Perard

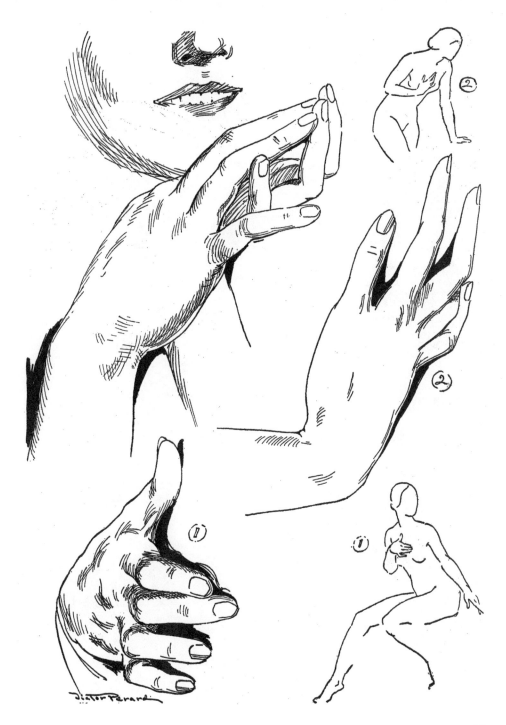

Victor Perard

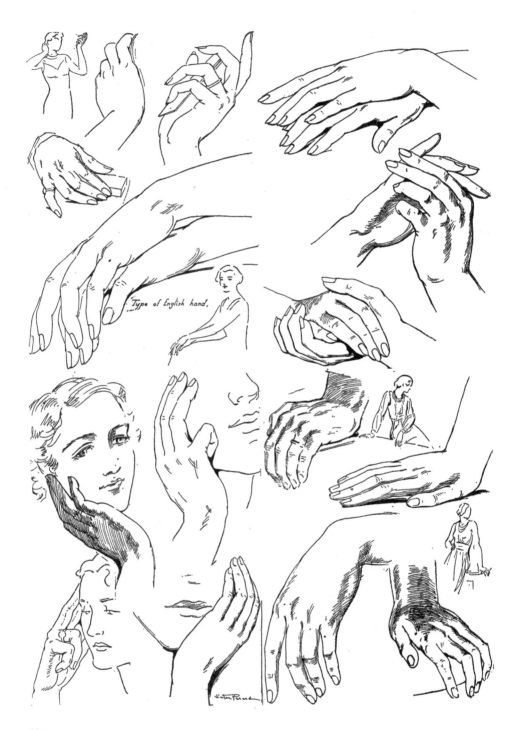

Type of English hand.

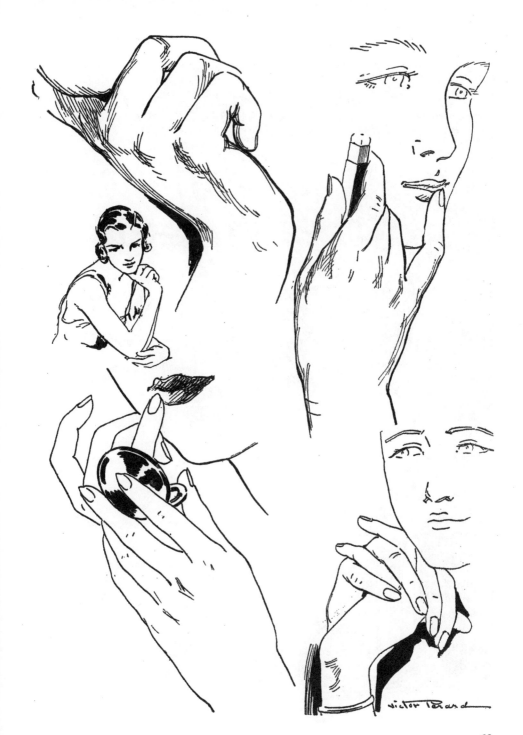

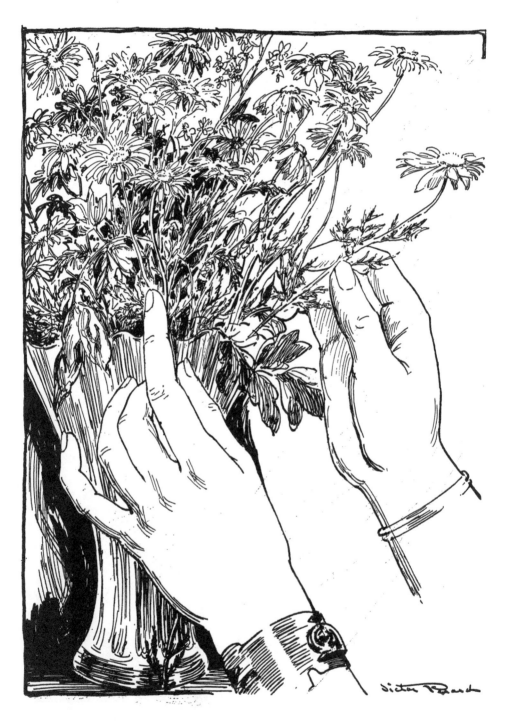

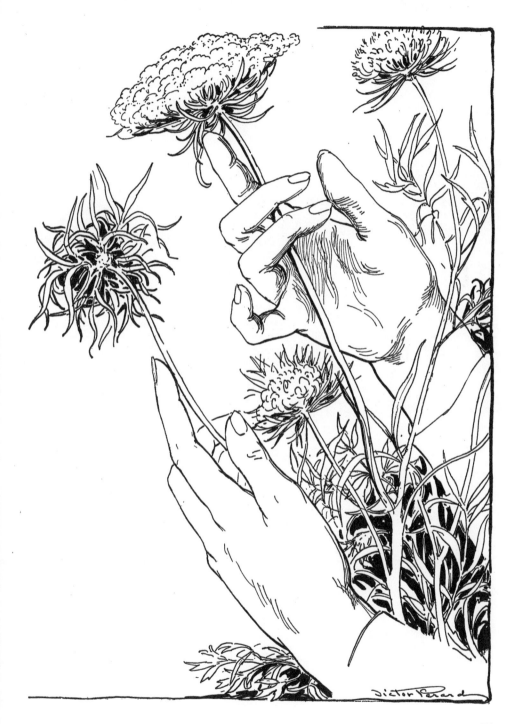

GROUP 4
HANDS as AIDS to
the FASHION ARTIST

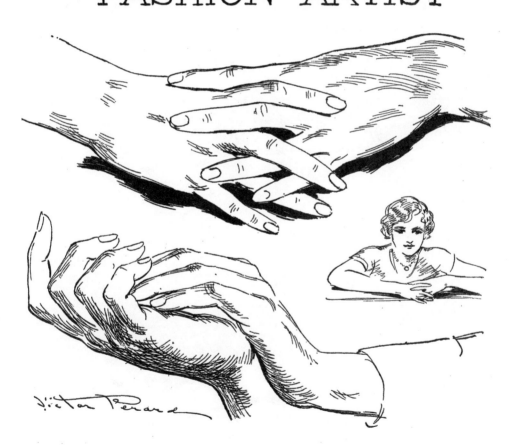

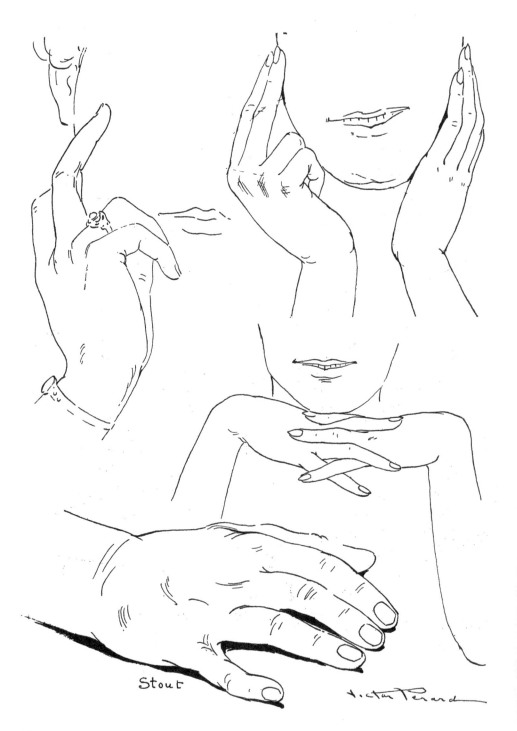

Stout

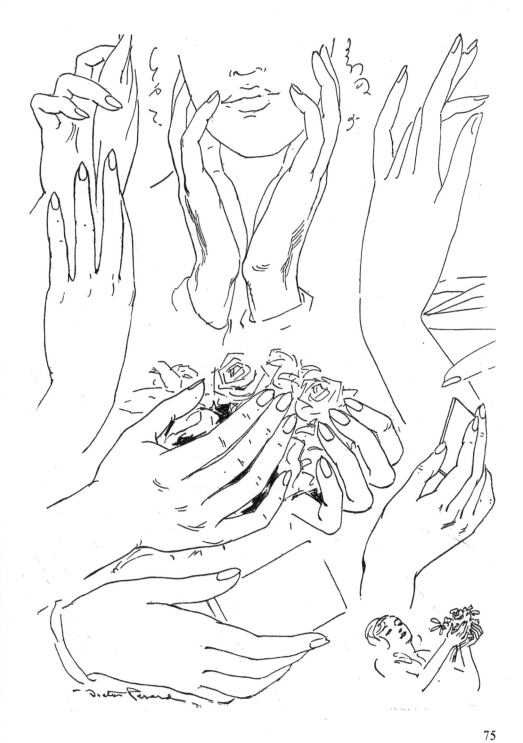

75

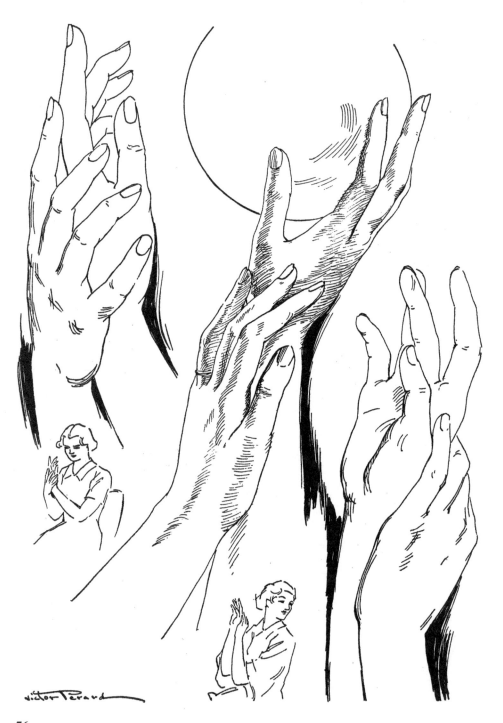

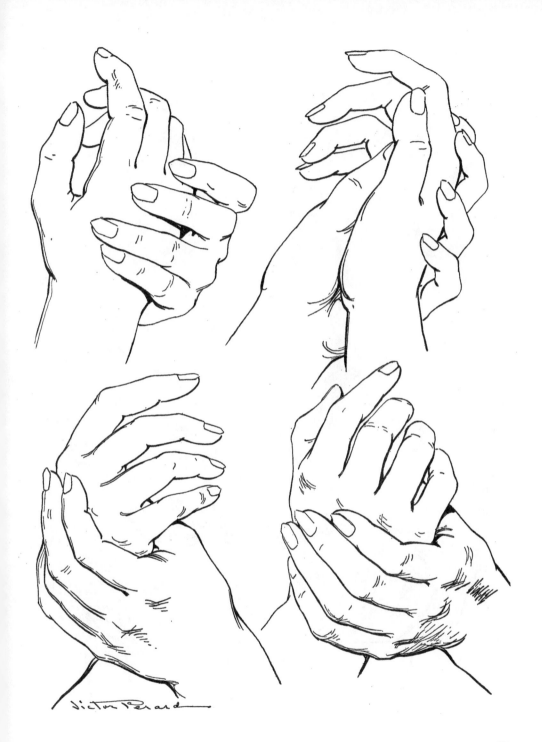

Victor Perard

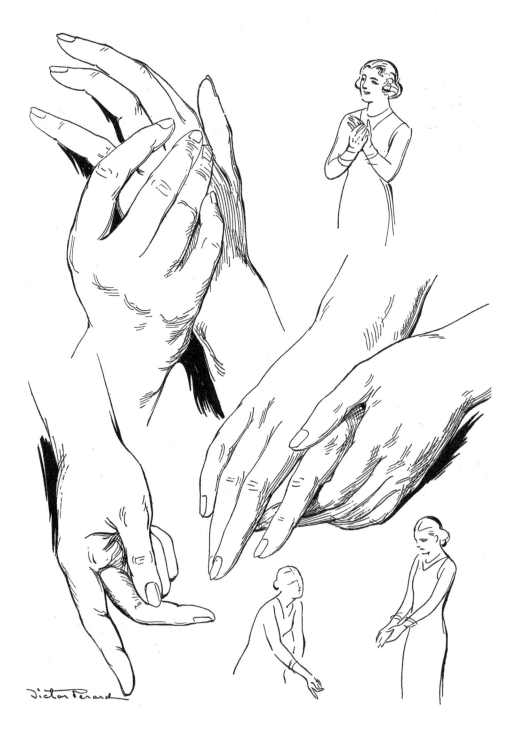

Victor Perard

78

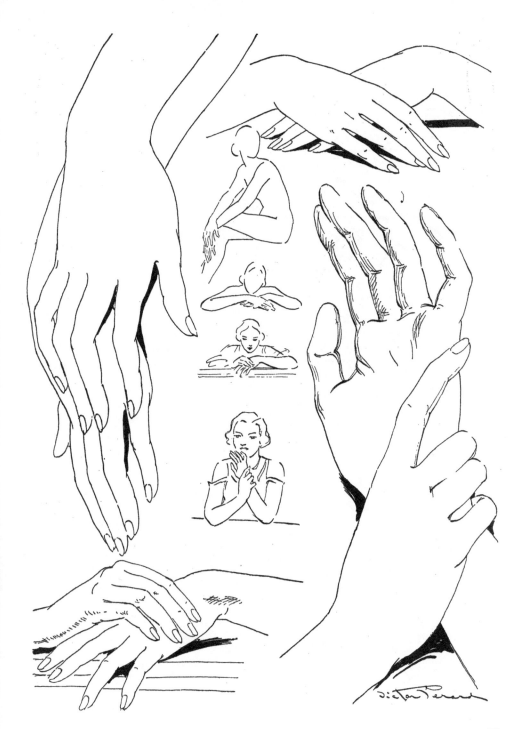

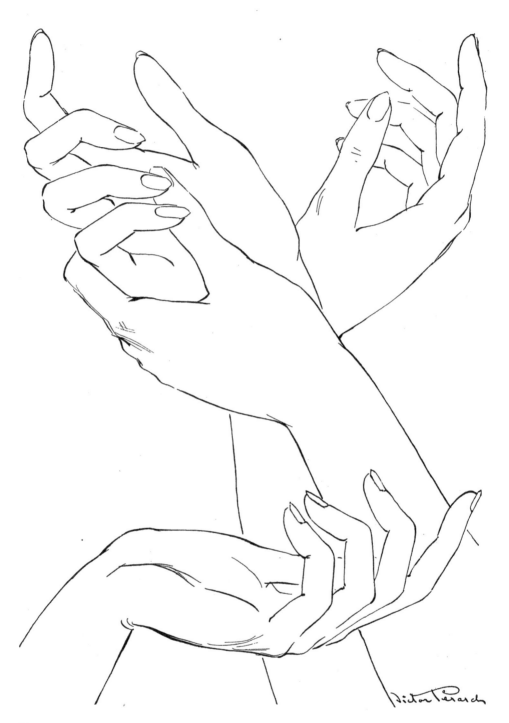

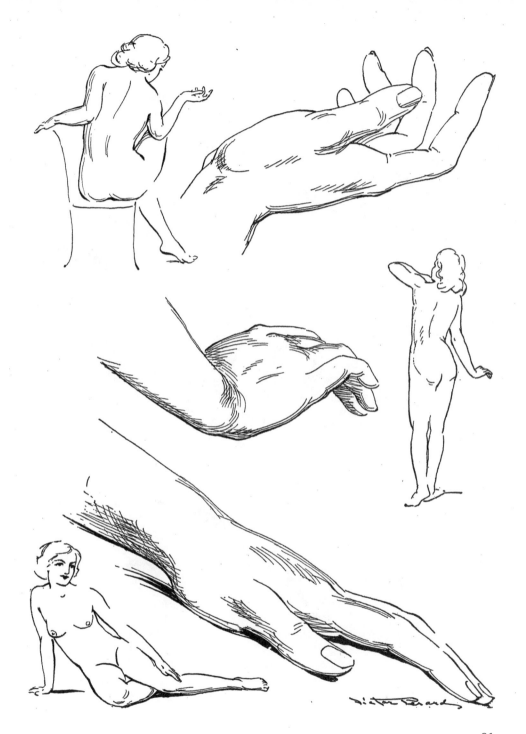

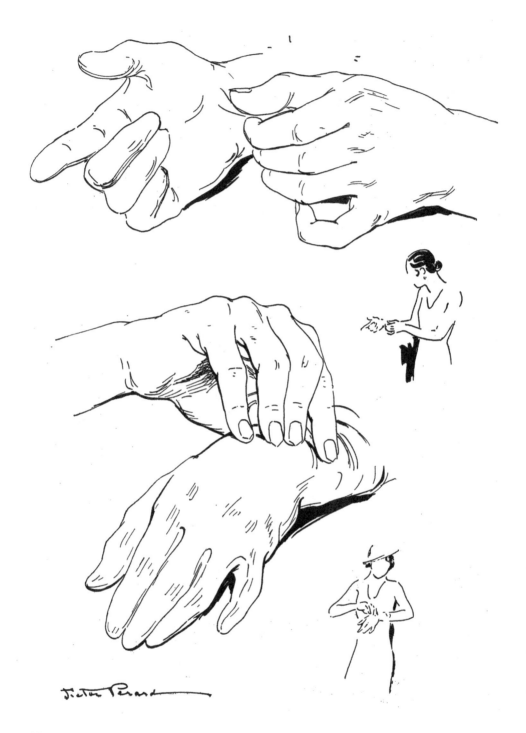

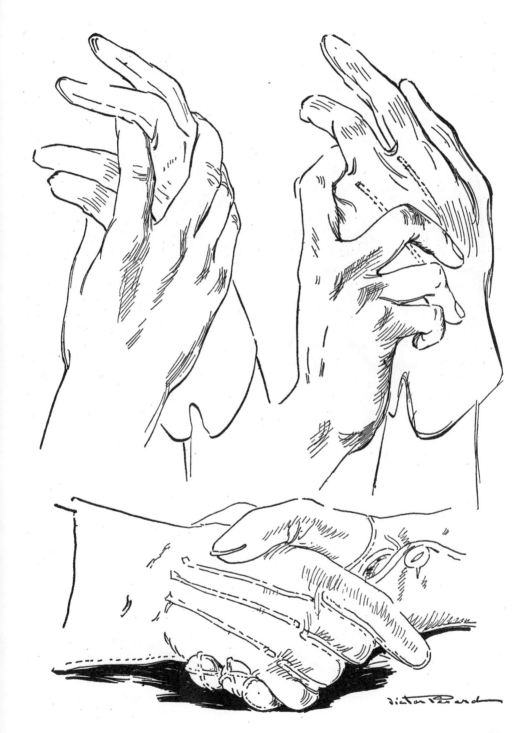

83

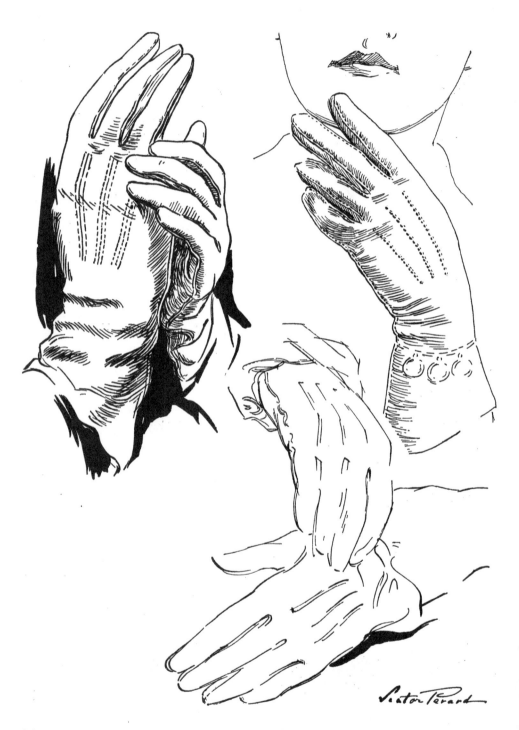

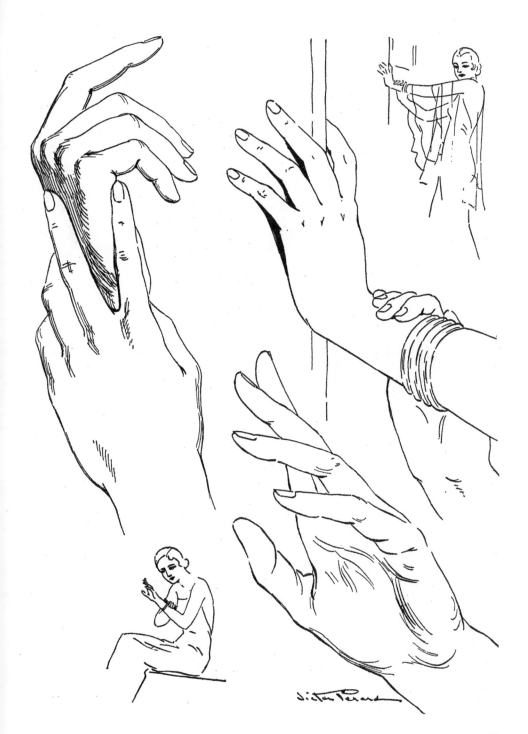

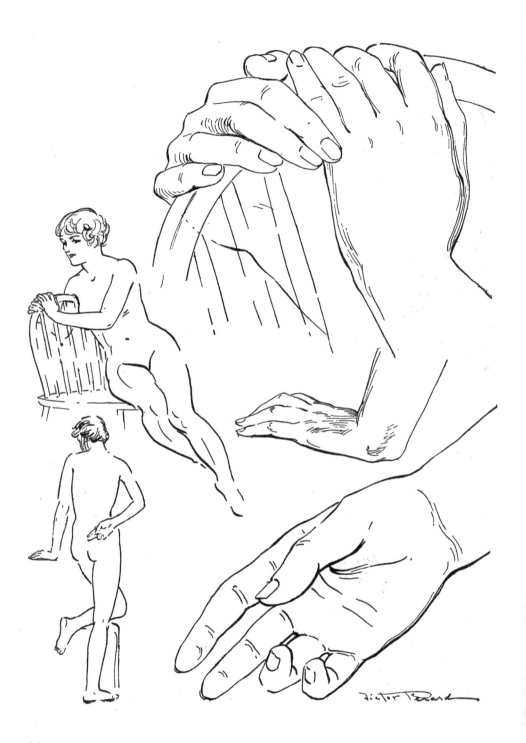

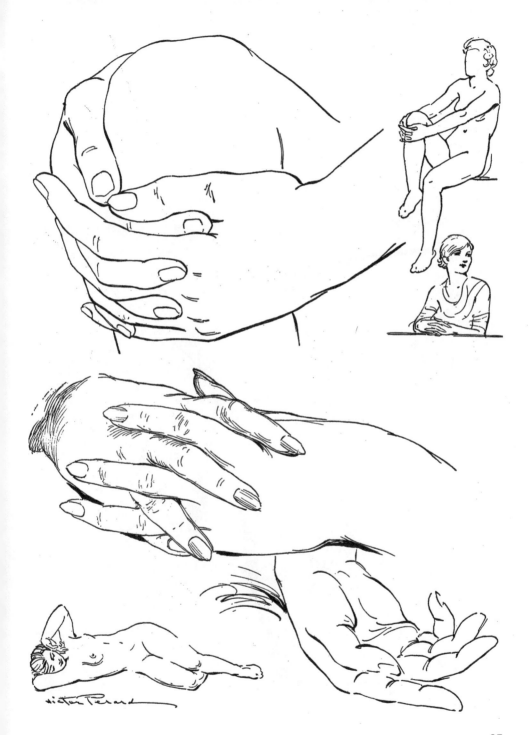

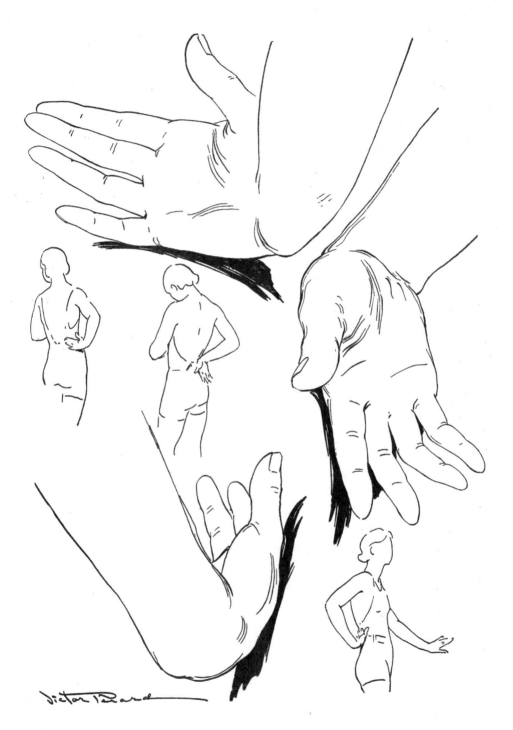

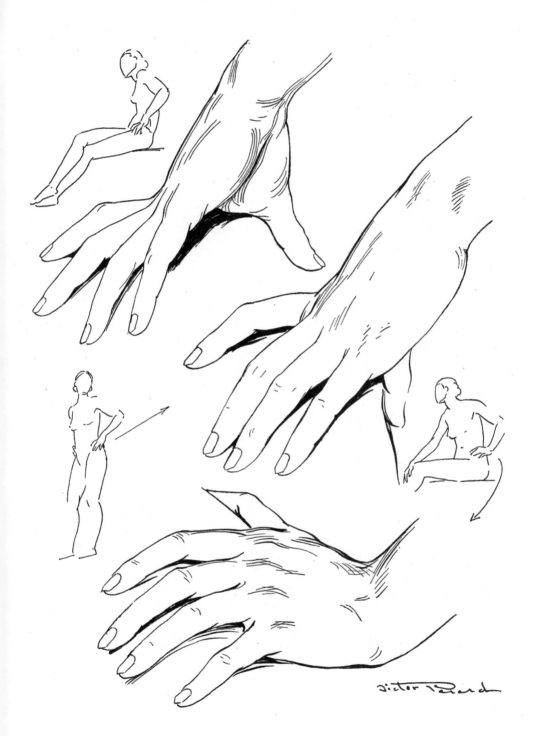

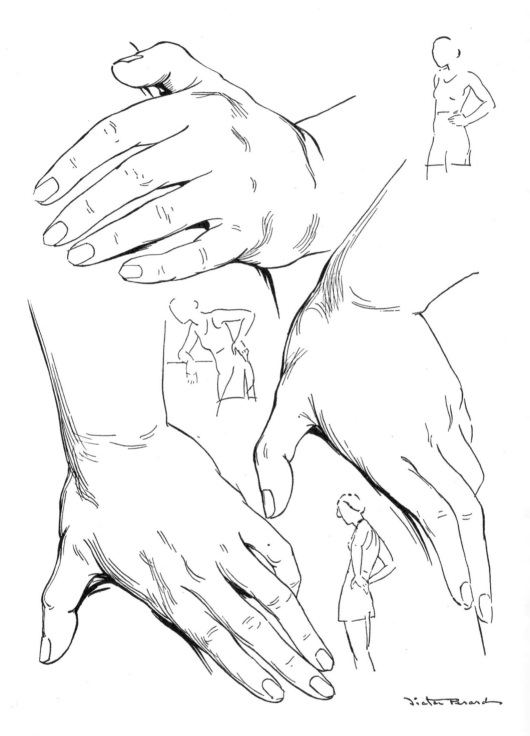

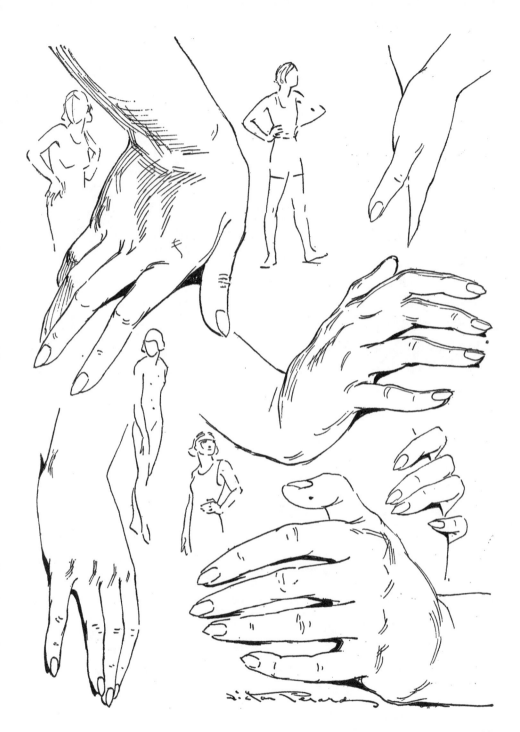

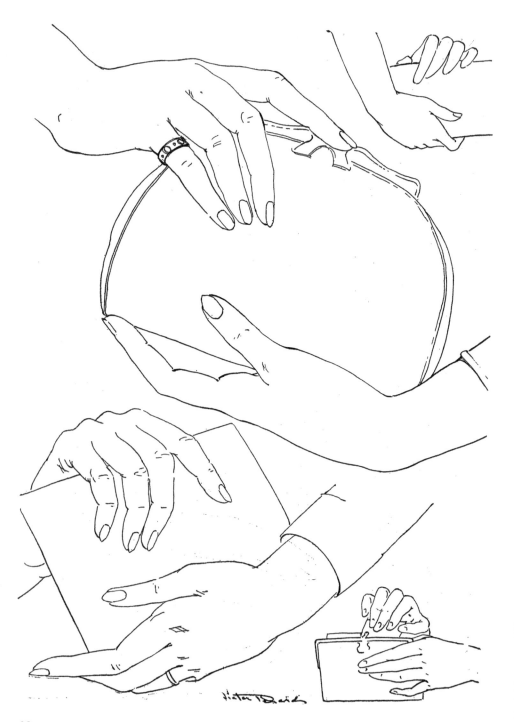

92

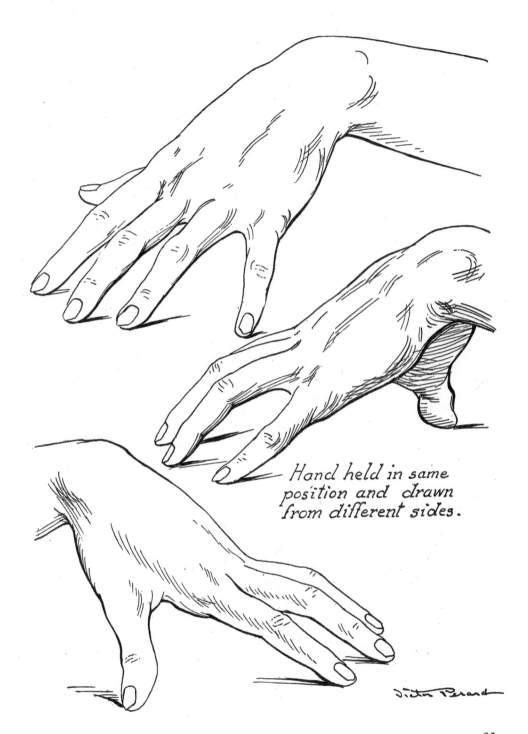

*Hand held in same
position and drawn
from different sides.*

Victor Perard

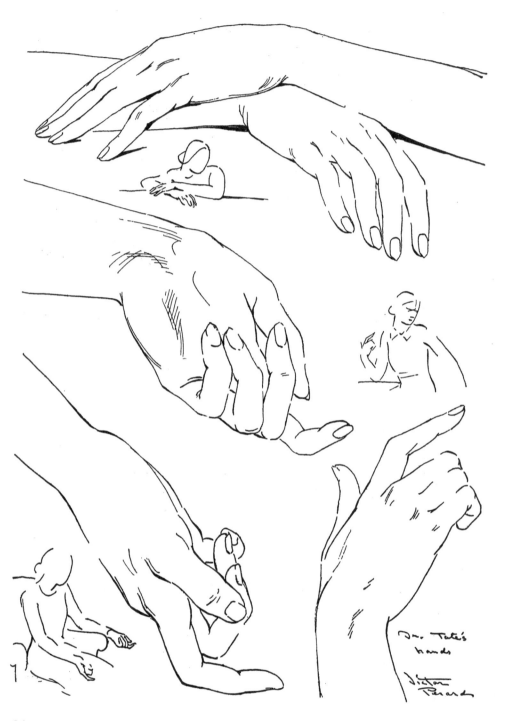

Dr. Tate's
hands

Victor
Perard

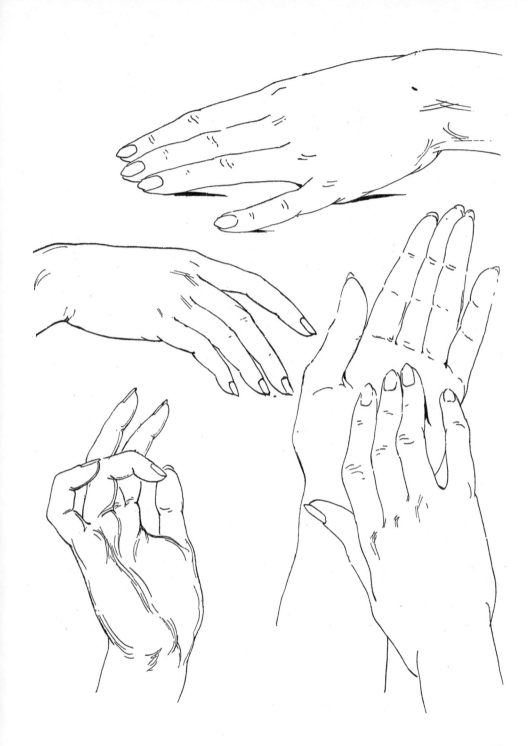

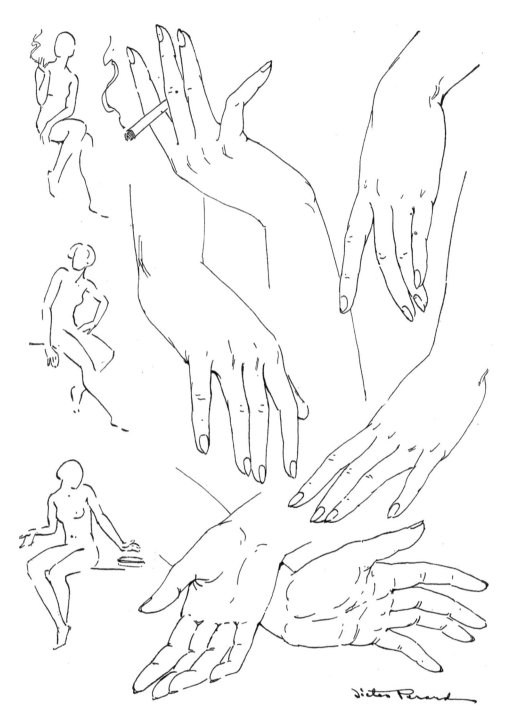

Victor Perard

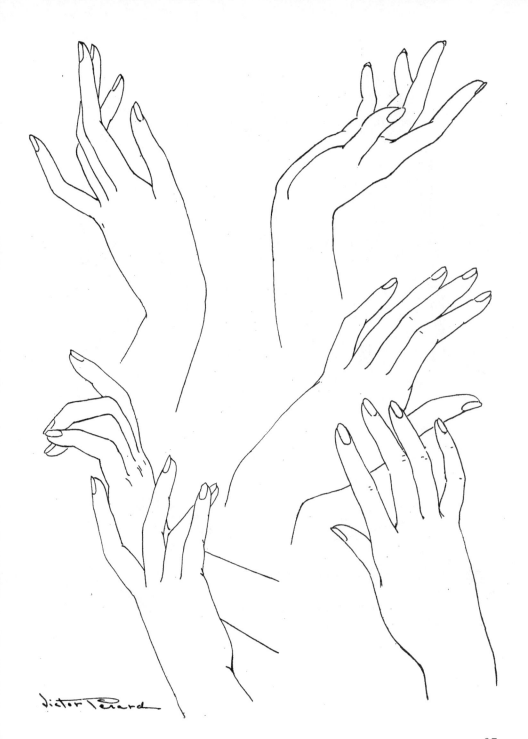

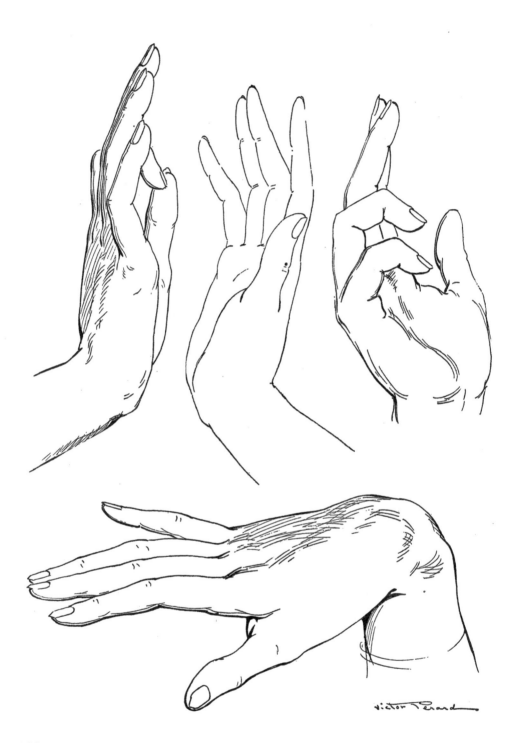

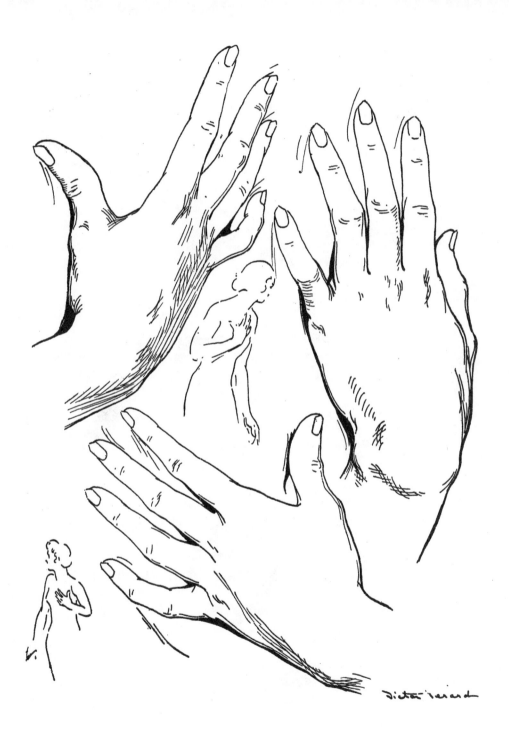

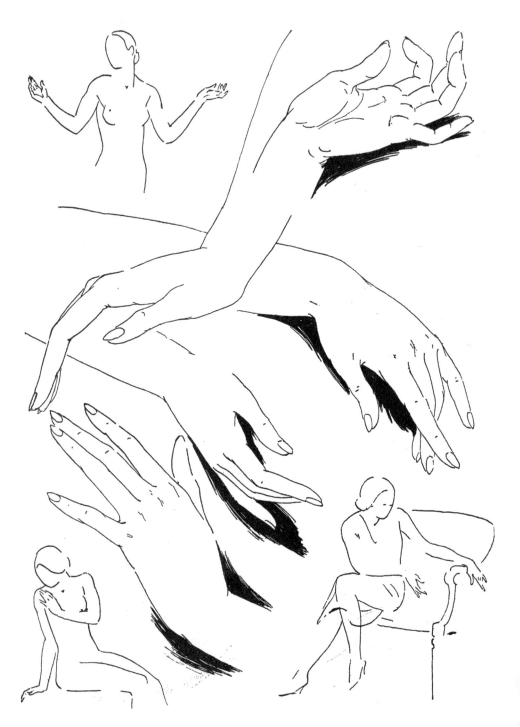

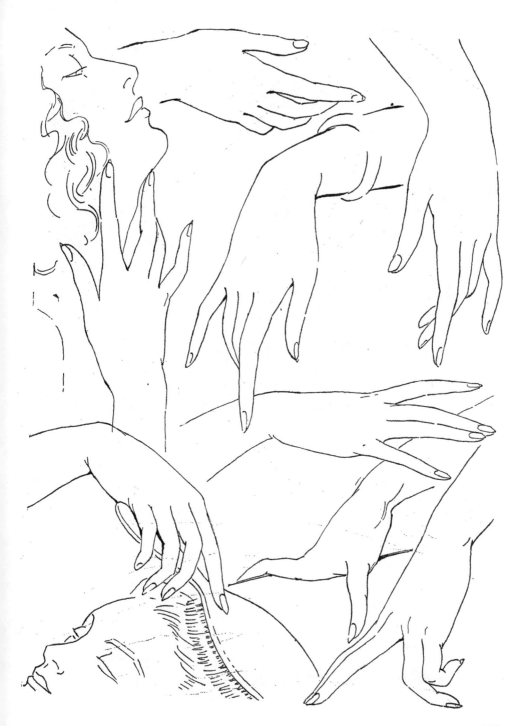

101

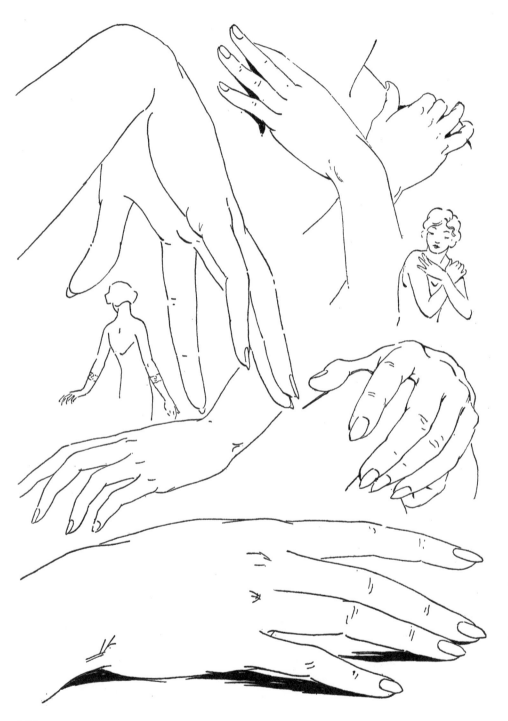

102

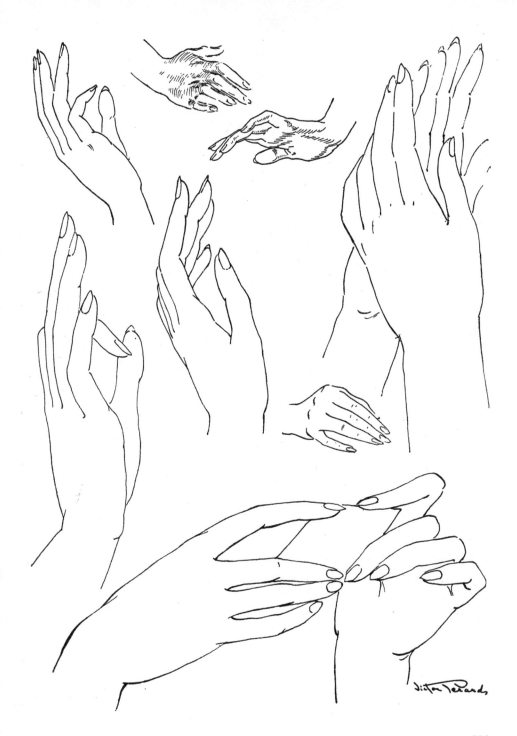

103

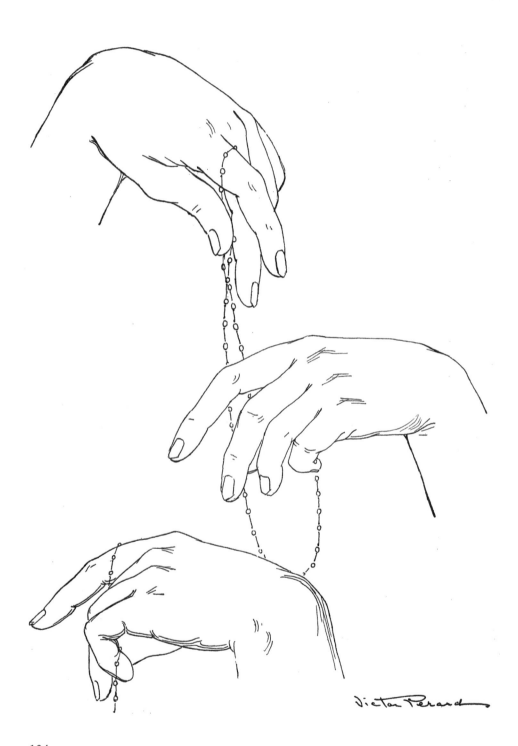

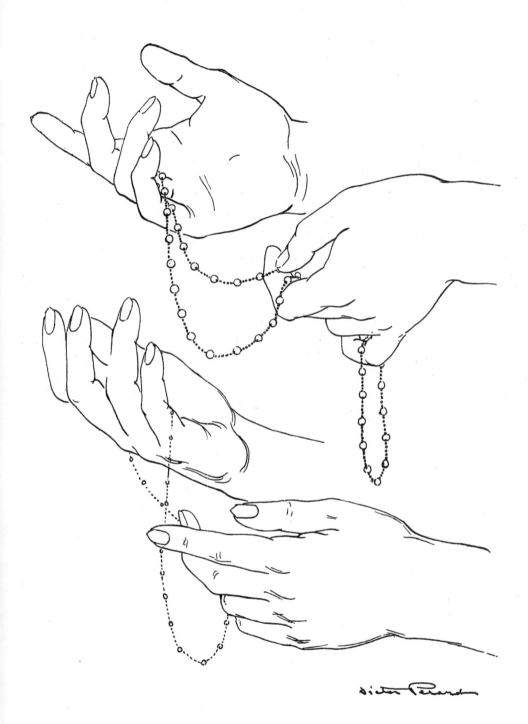

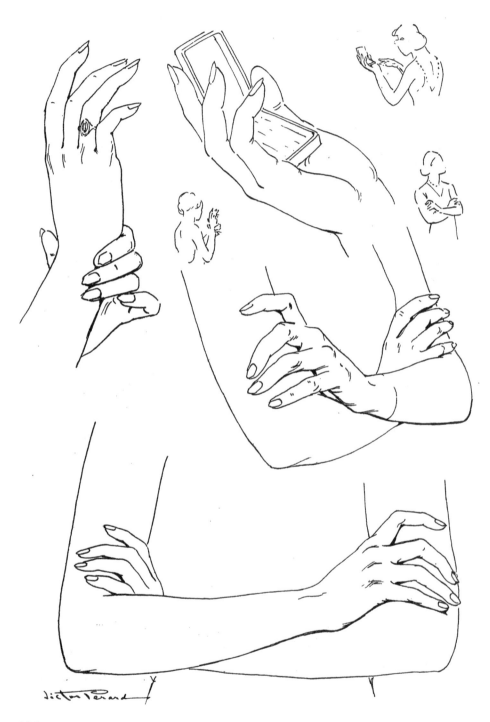

Victor Perard

106

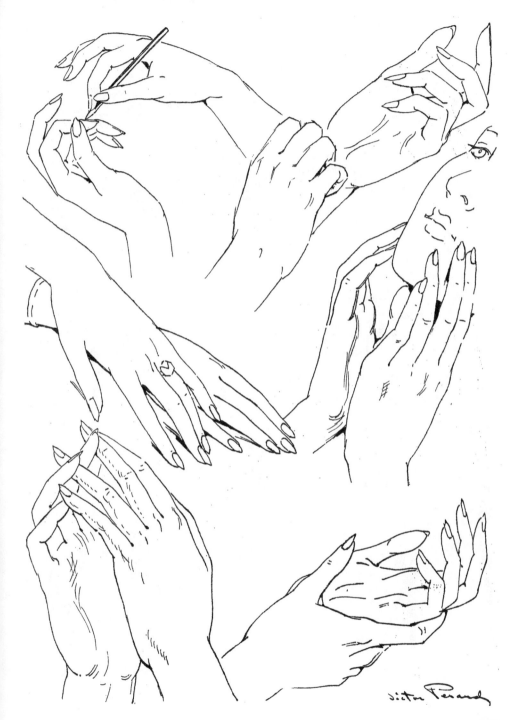

107

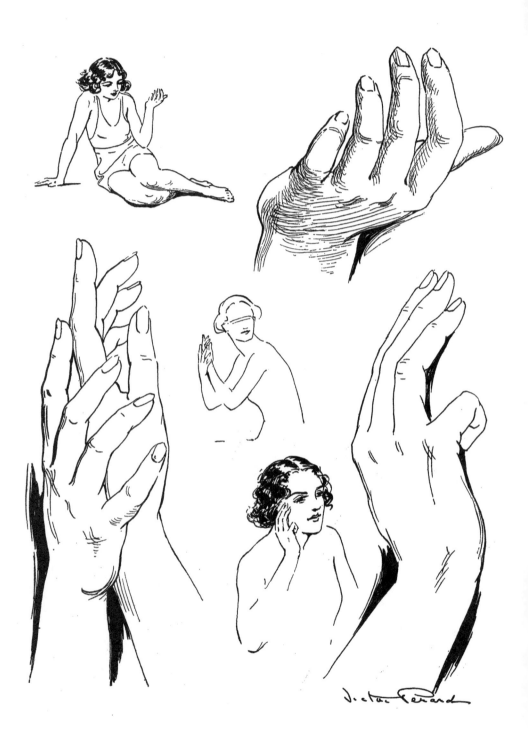

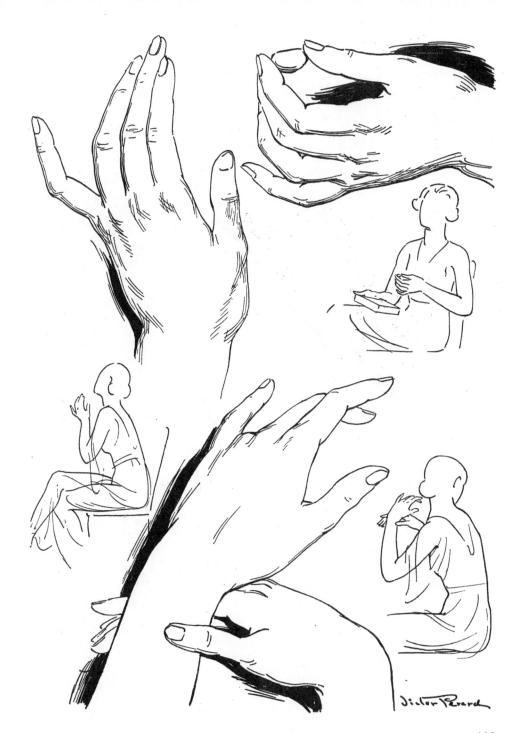

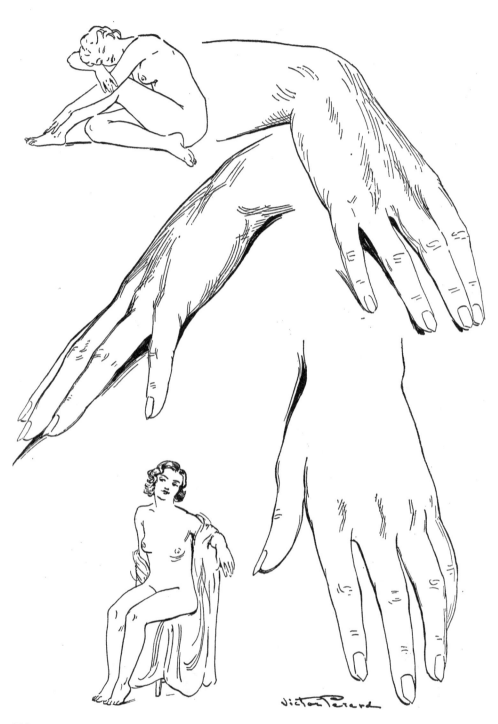

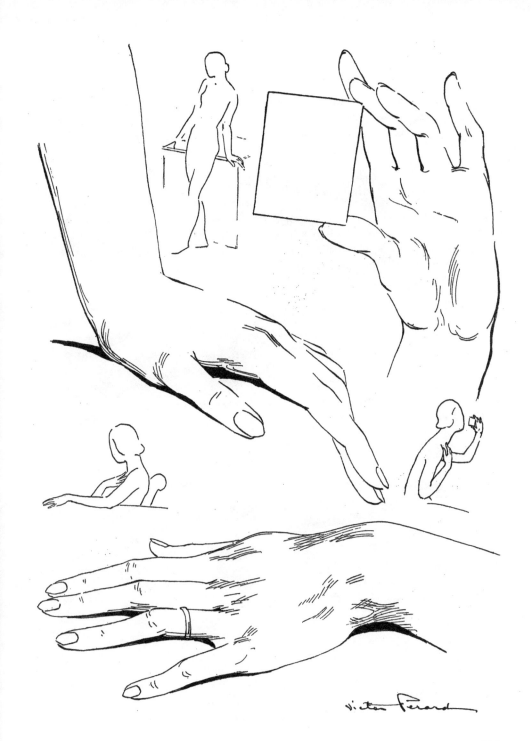

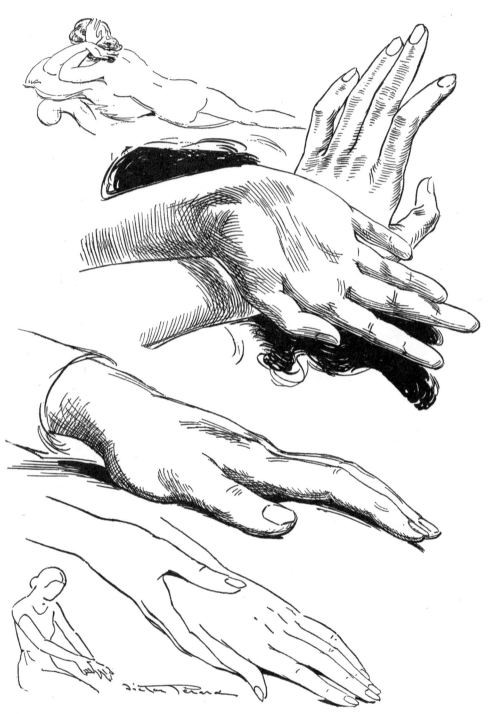

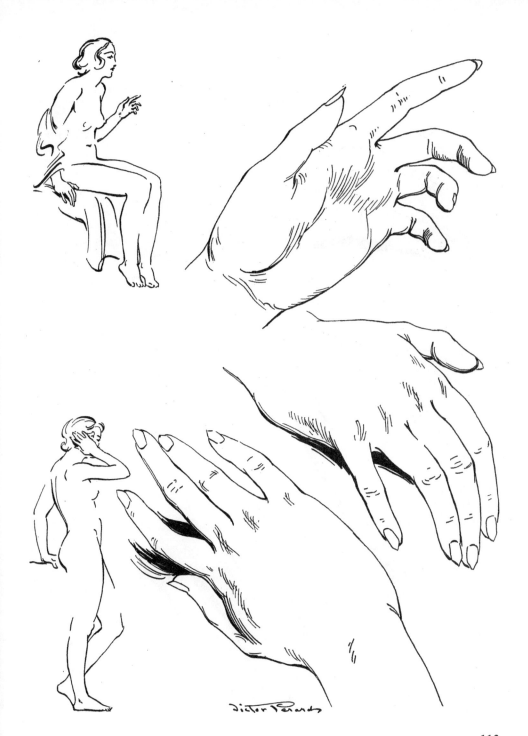

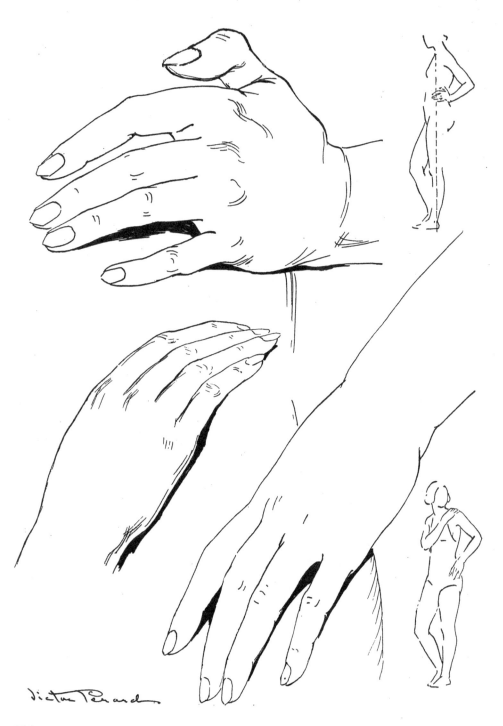

Victor Perard

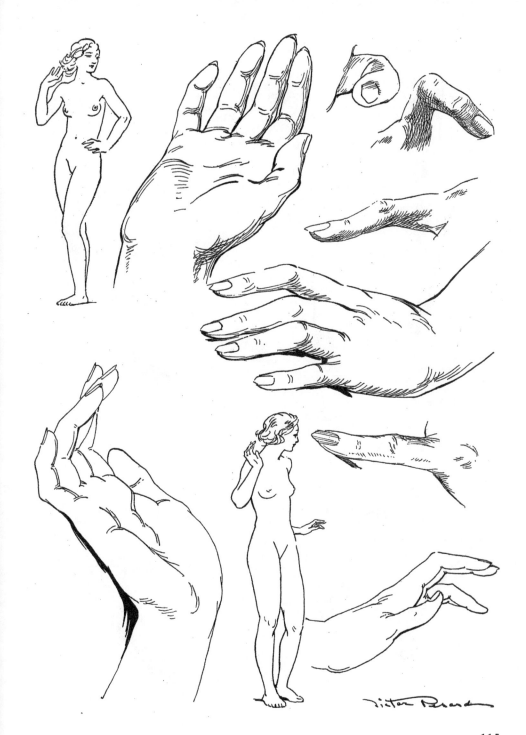

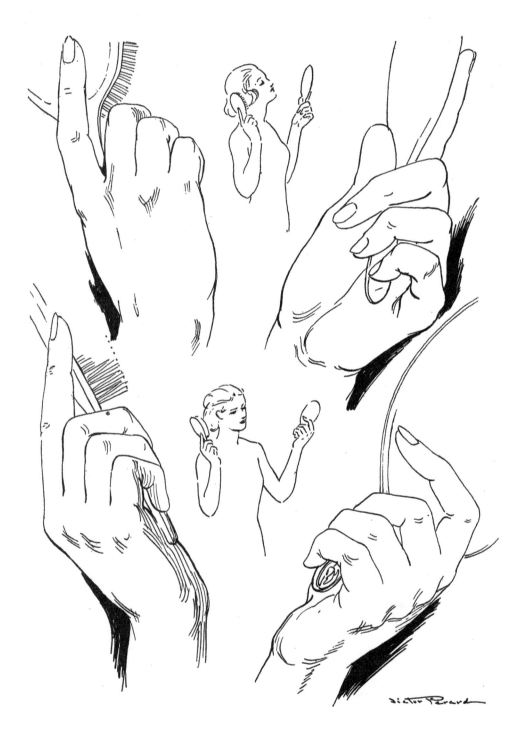

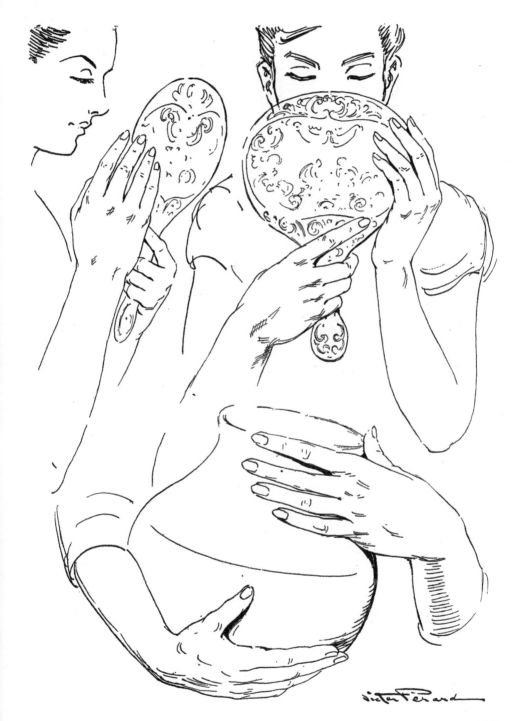

117

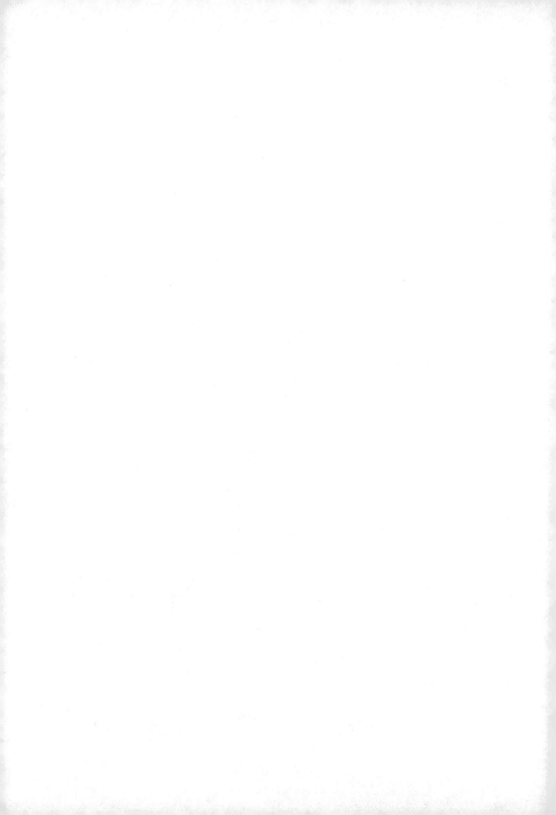

GROUP 5
MEN'S HANDS
BUSINESS MEN and EXECUTIVES

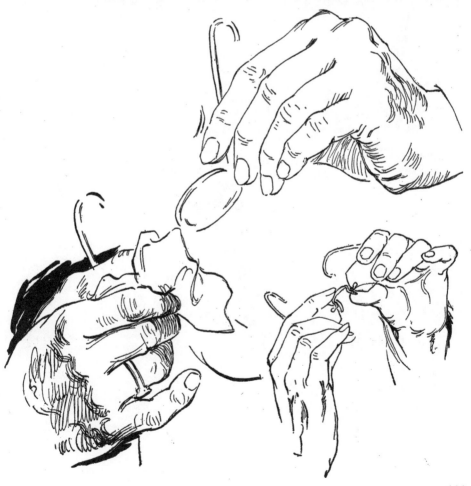

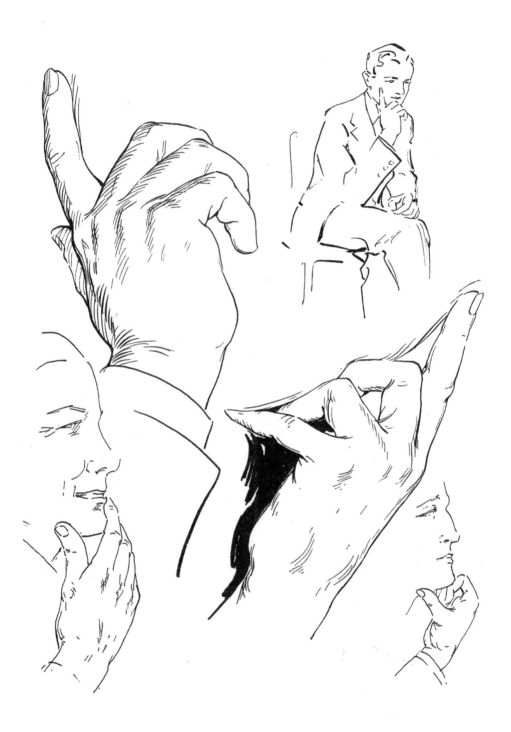

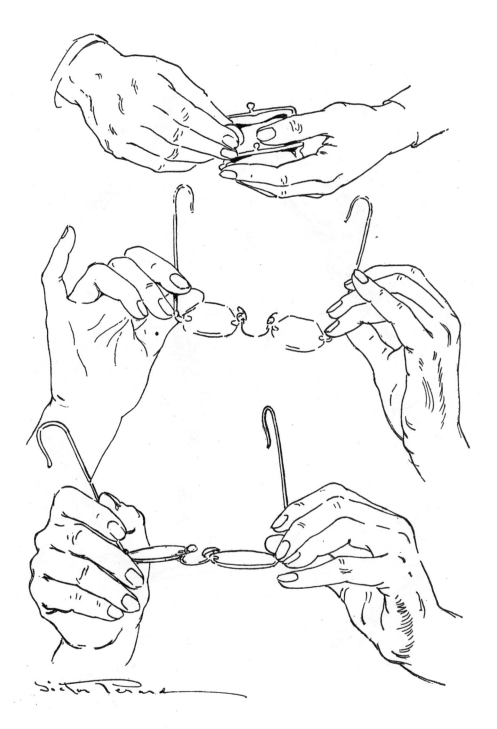

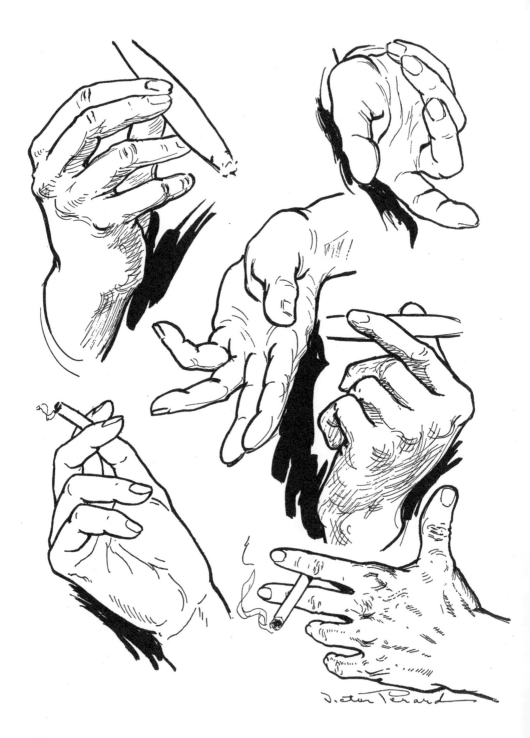

122

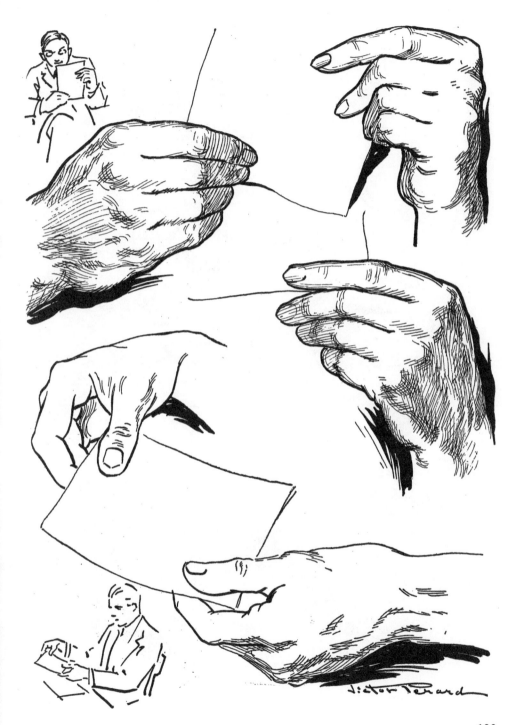

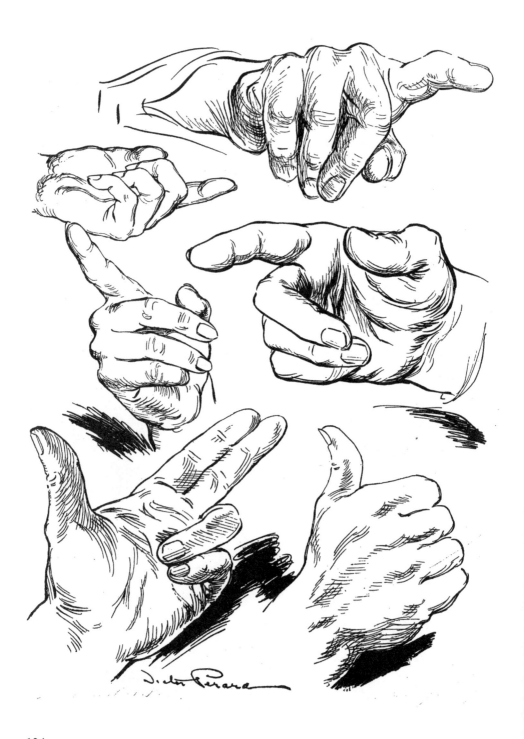

124

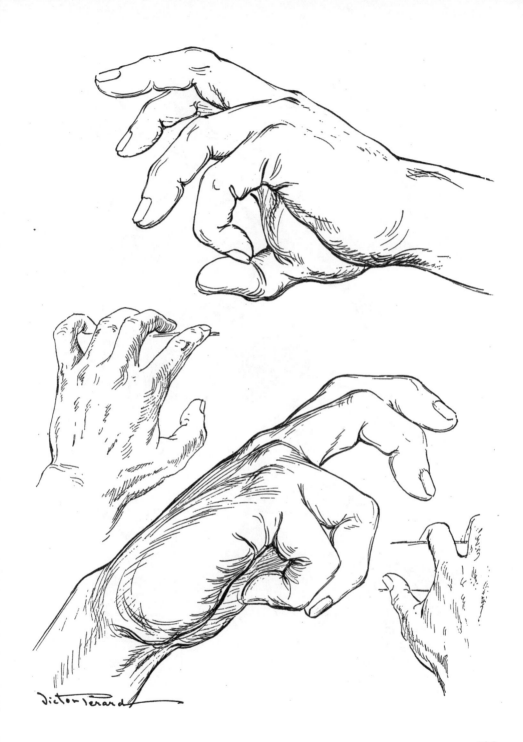

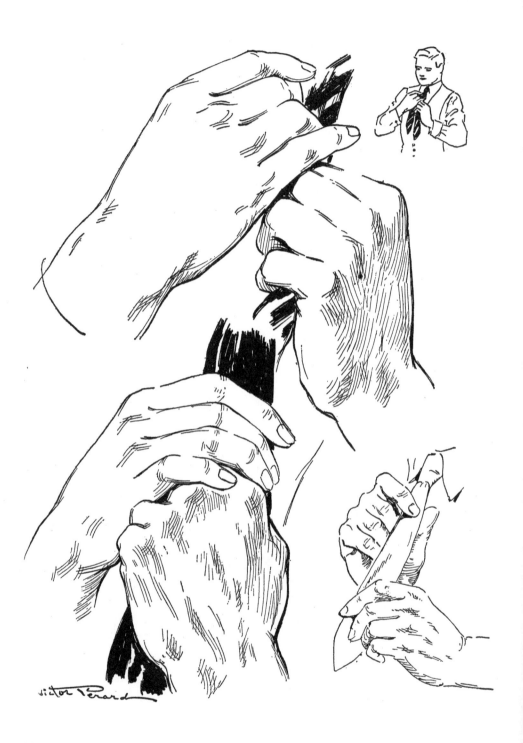

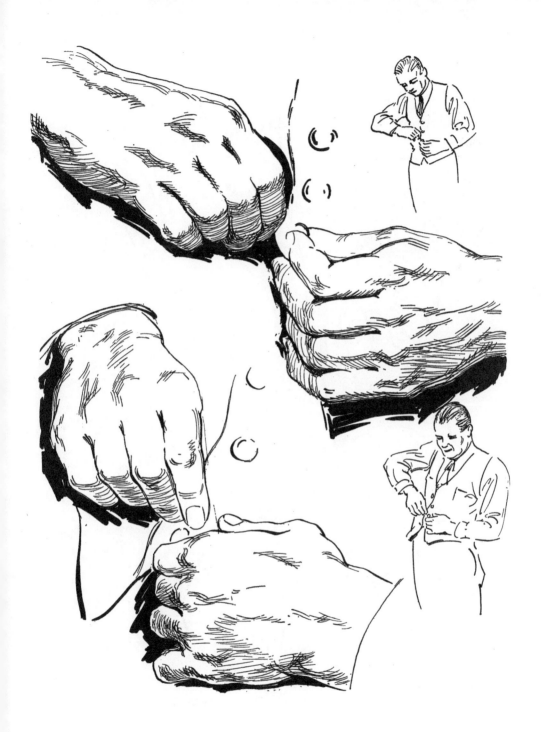

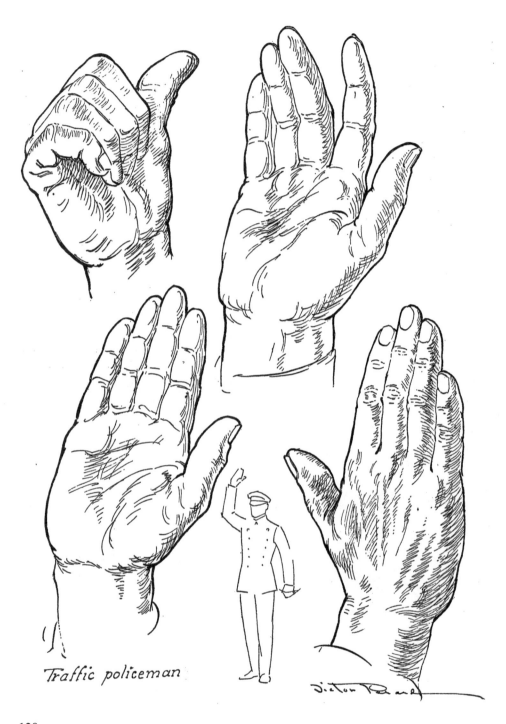

Traffic policeman

128

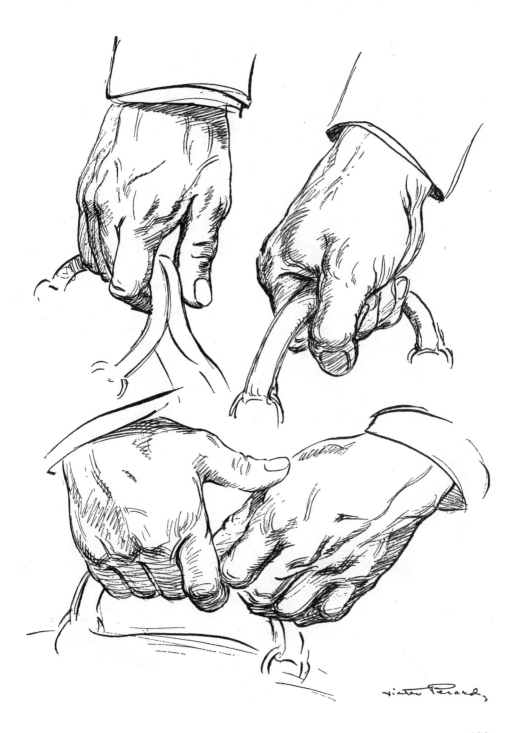

Victor Perard

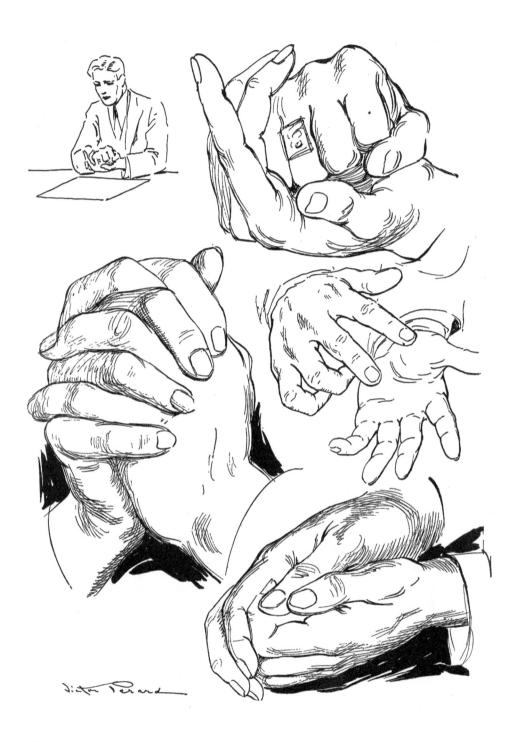

130

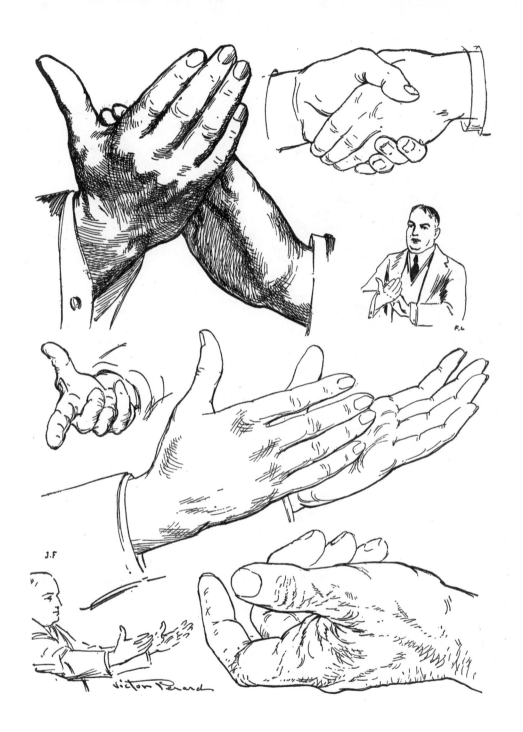

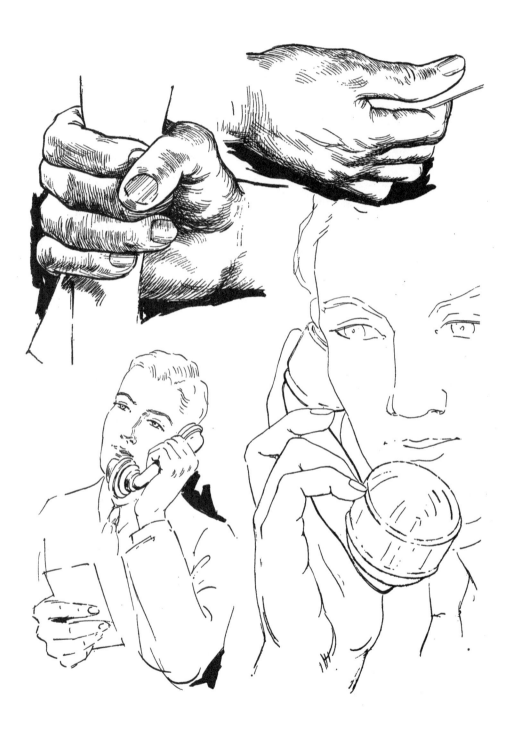

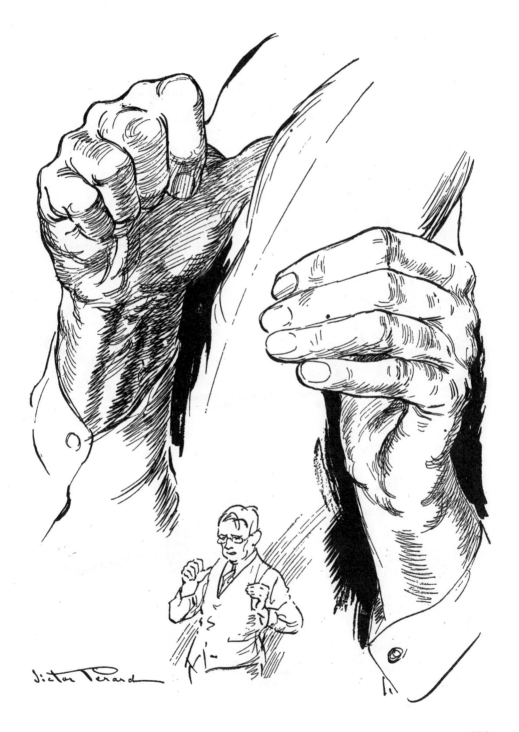

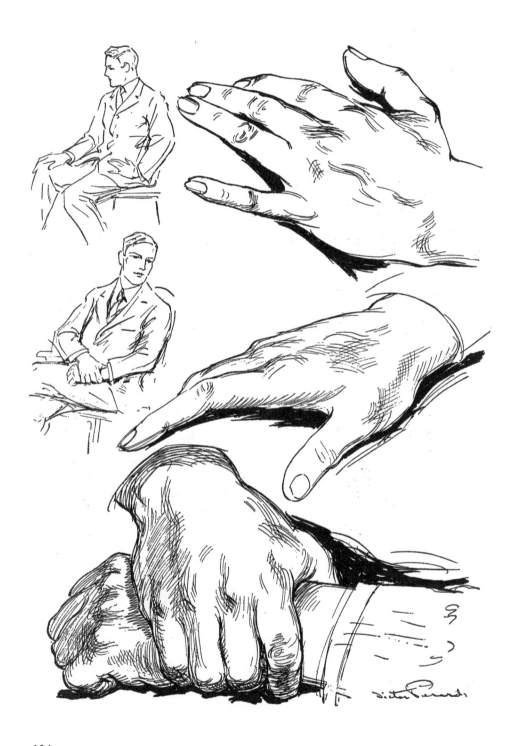

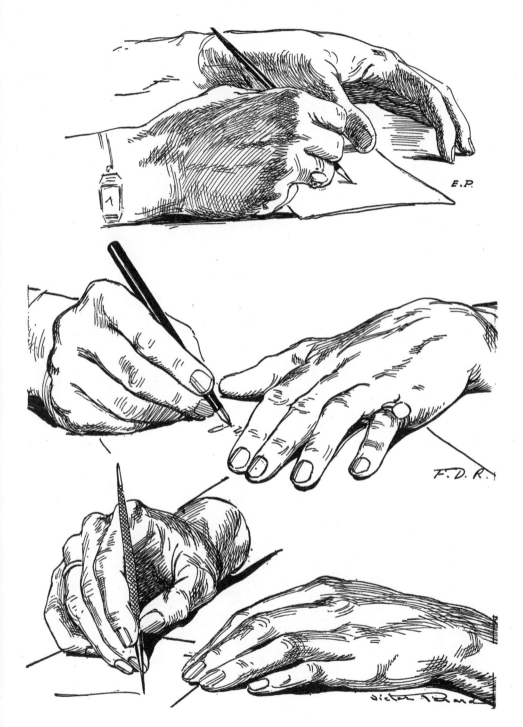

135

GROUP 6
HANDS in the PROFESSIONS

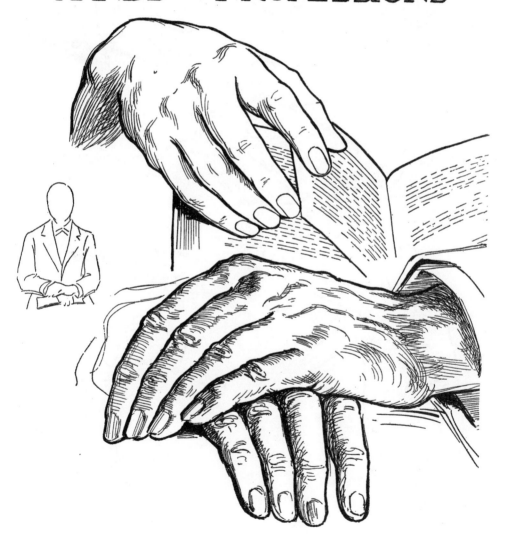

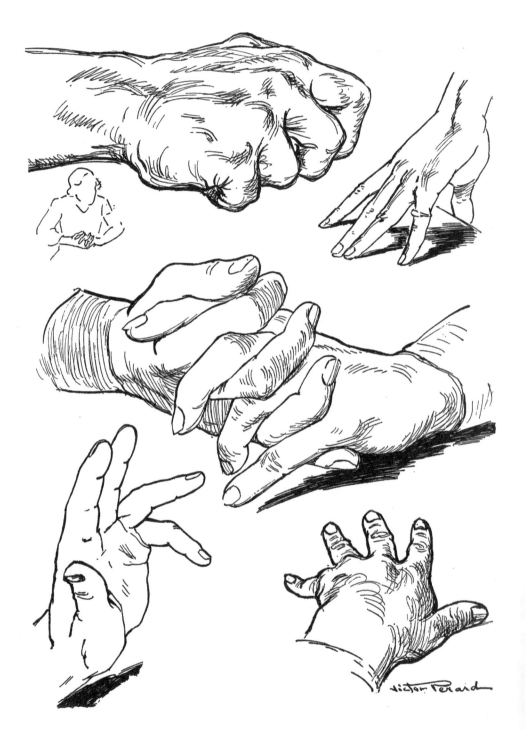

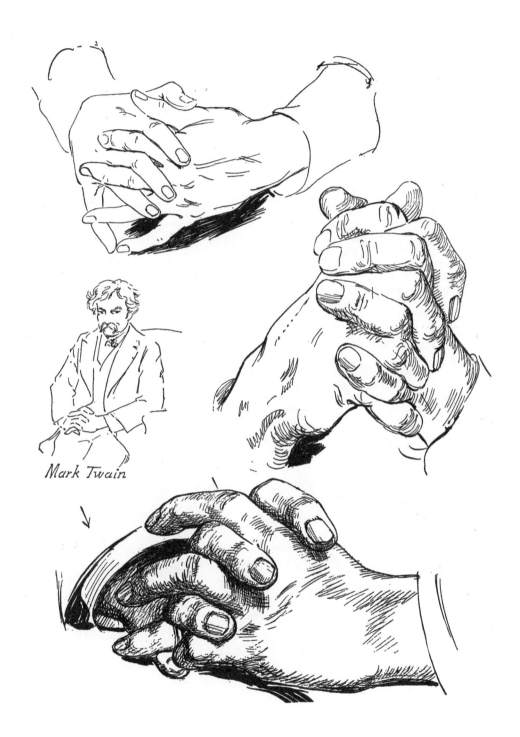

Mark Twain

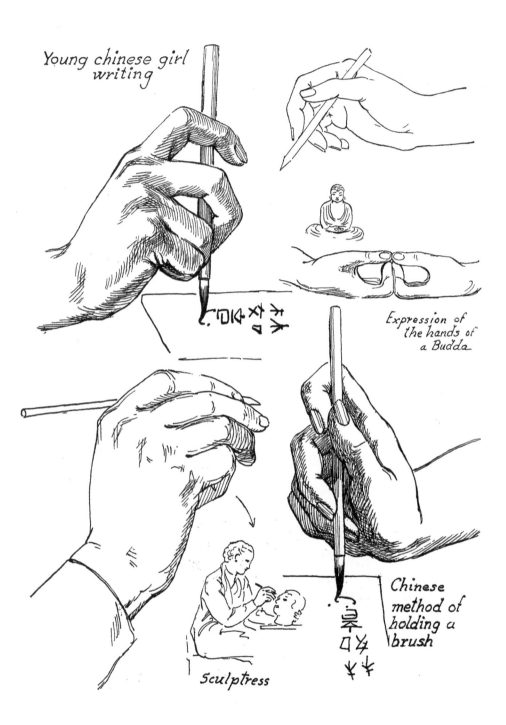

Young chinese girl writing

Expression of the hands of a Budda

Sculptress

Chinese method of holding a brush

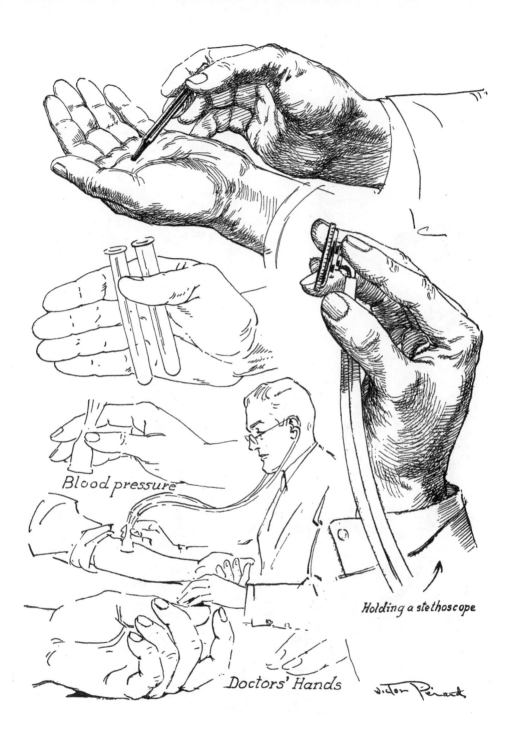

Blood pressure

Holding a stethoscope

Doctors' Hands

Victor Perard

141

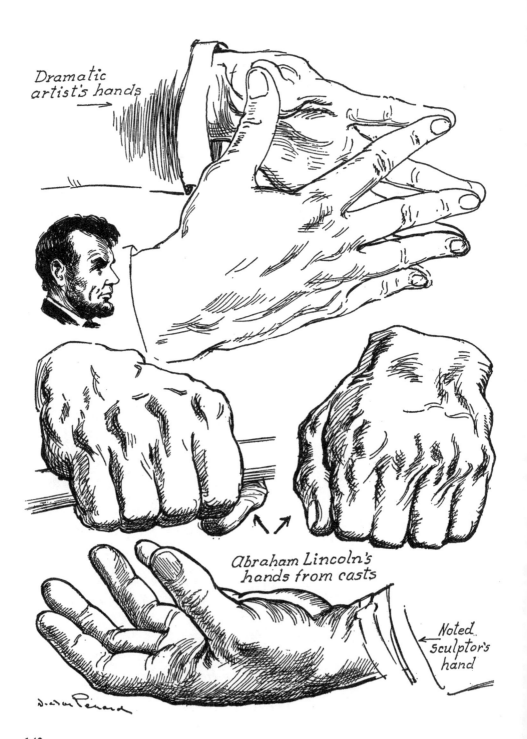

Dramatic
artist's hands

Abraham Lincoln's
hands from casts

Noted
sculptor's
hand

142

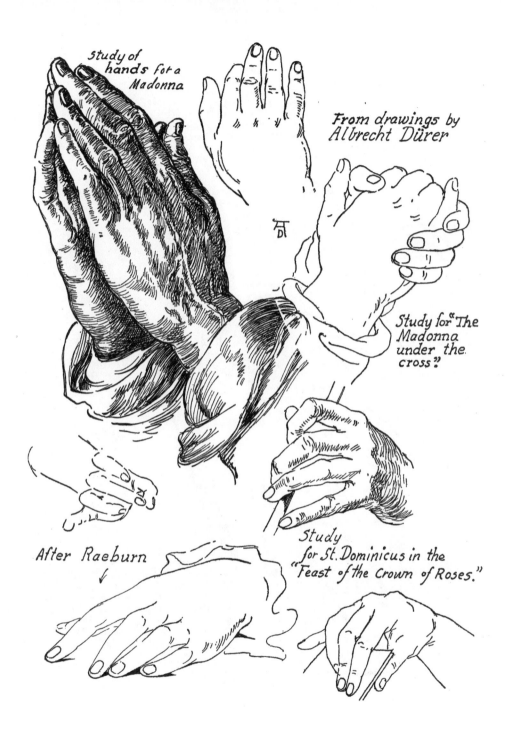

study of
hands for a
Madonna

From drawings by
Albrecht Dürer

Study for "The
Madonna
under the
cross."

Study
for St. Dominicus in the
"Feast of the Crown of Roses."

After Raeburn

143

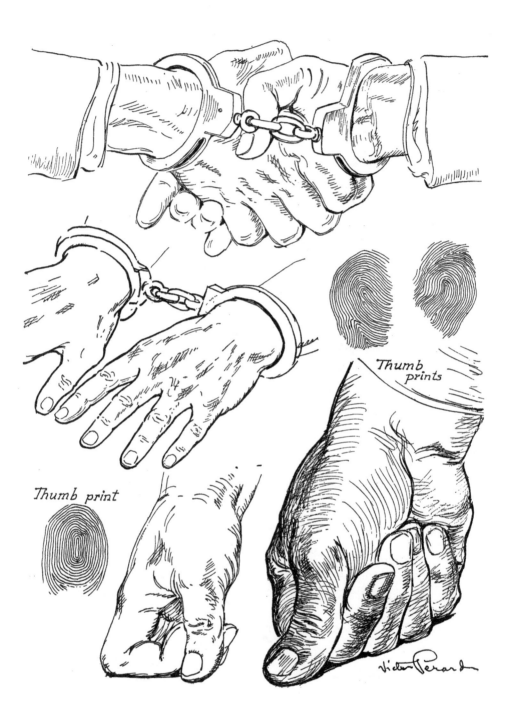

Thumb print

Thumb prints

Victor Perard

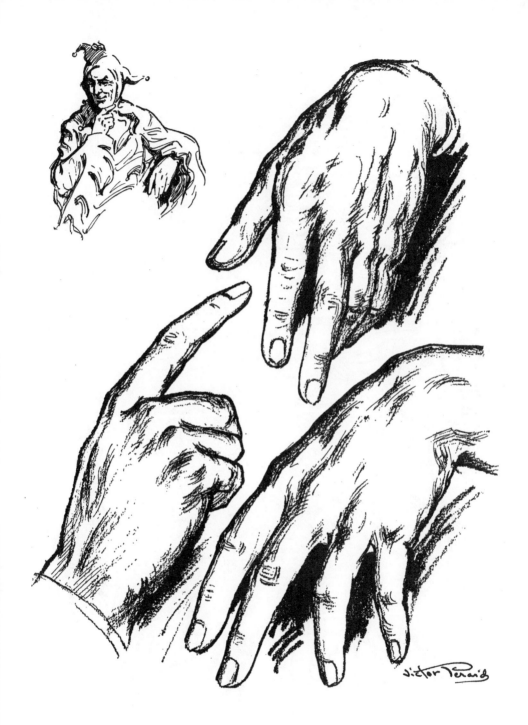

145

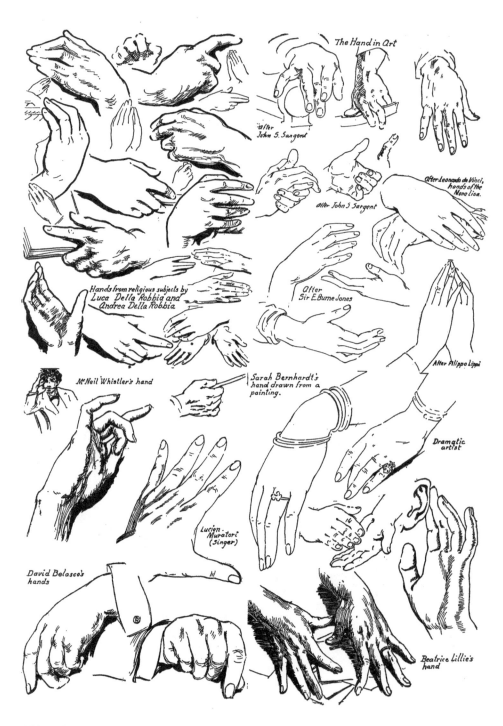

The Hand in Art

After John S. Sargent

After John S. Sargent

After Leonardo da Vinci, hands of the Mona Lisa.

After Sir E. Burne Jones

Hands from religious subjects by
Luca Della Robbia and
Andrea Della Robbia

After Filippo Lippi

Mc Neil Whistler's hand

Sarah Bernhardt's hand drawn from a painting.

Dramatic artist

Lucien Muratori (Singer)

David Belasco's hands

Beatrice Lillie's hand

146

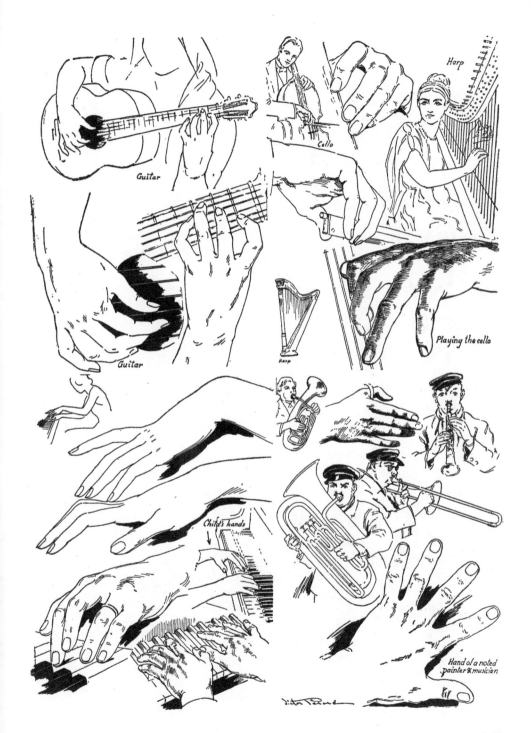

Guitar

Cello

Harp

Guitar

Harp

Playing the cello

Child's hands

Hand of a noted painter & musician

147

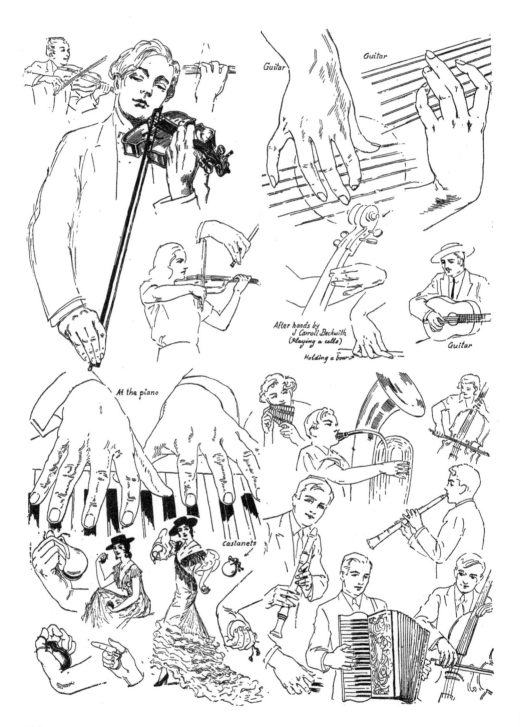

Guitar

Guitar

After hands by
J. Carroll Beckwith
(Playing a cello)

Holding a bow

Guitar

At the piano

Castanets

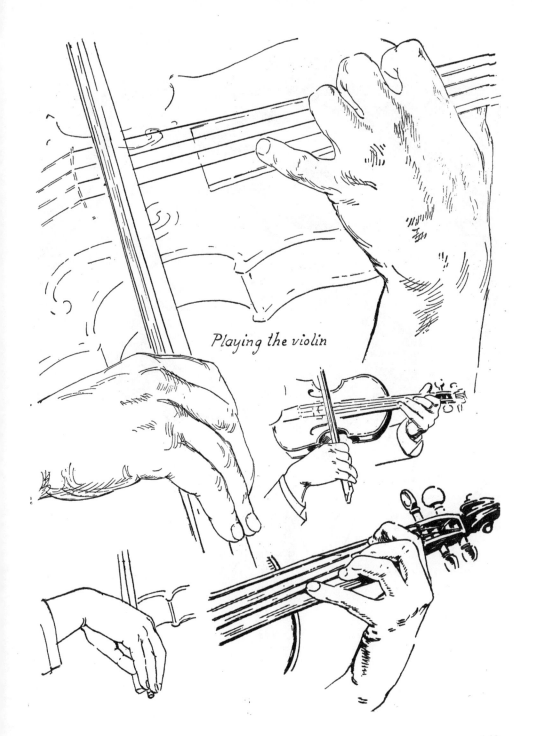

Playing the violin

149

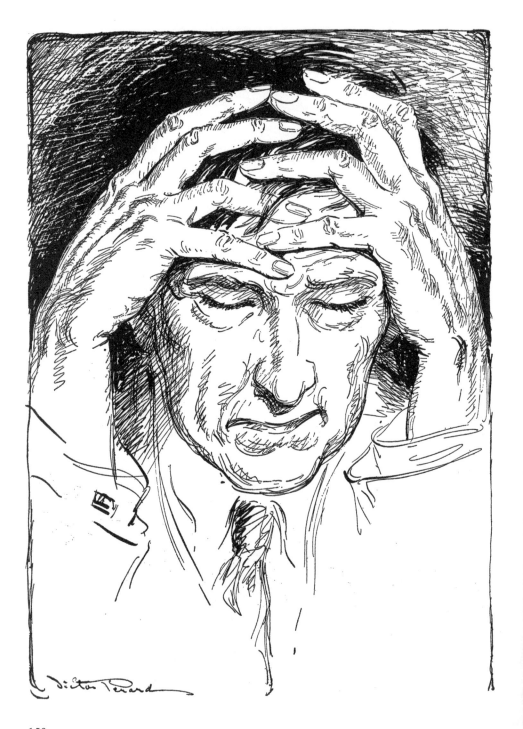

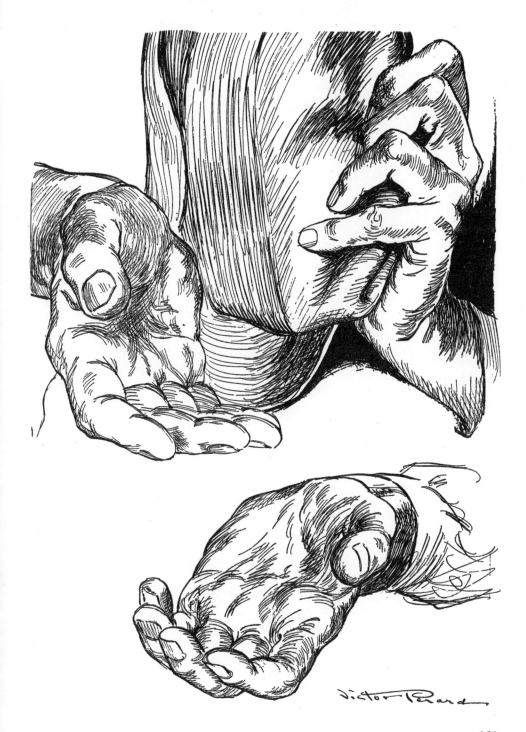

GROUP 7
HANDS in the TRADES

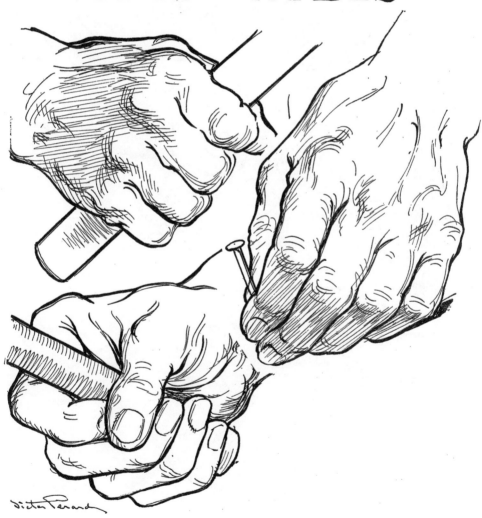

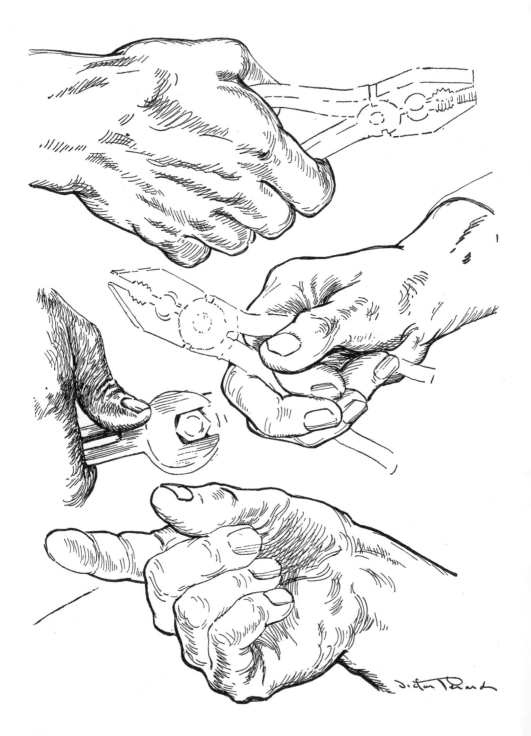

154

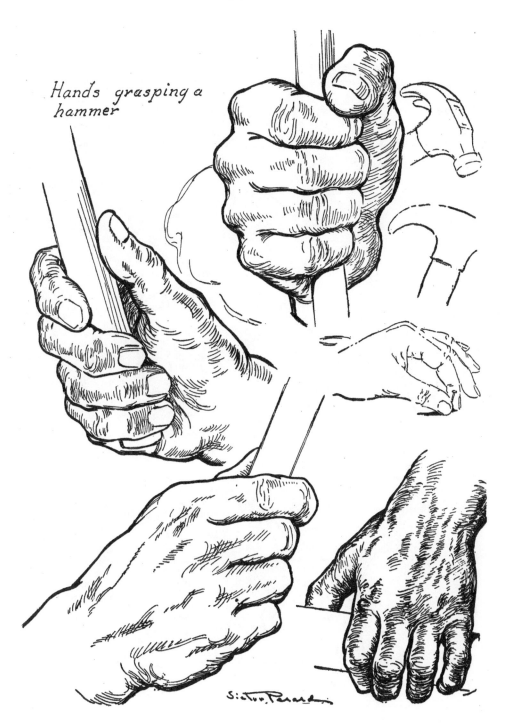

Hands grasping a
hammer

155

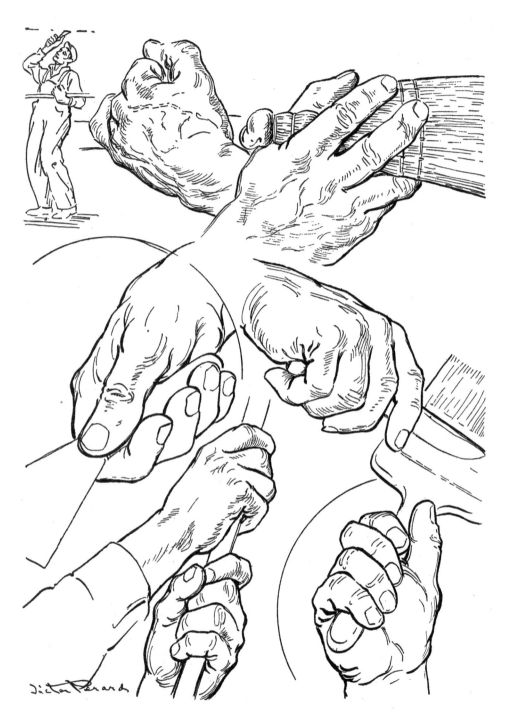

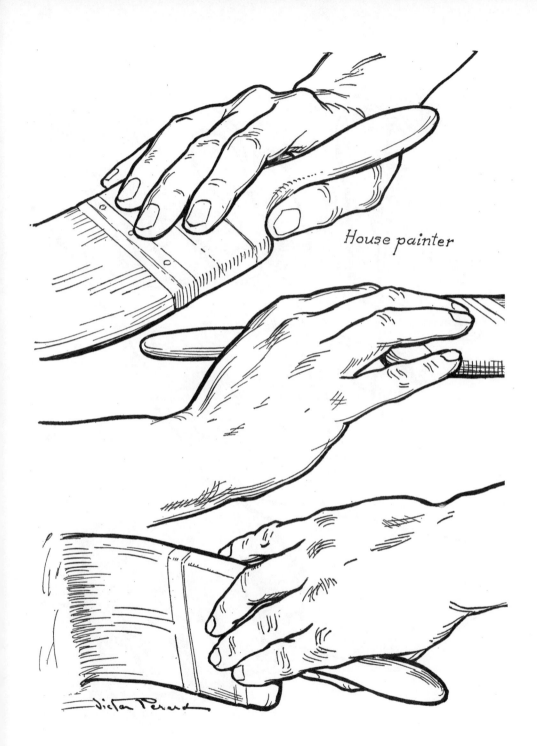

House painter

157

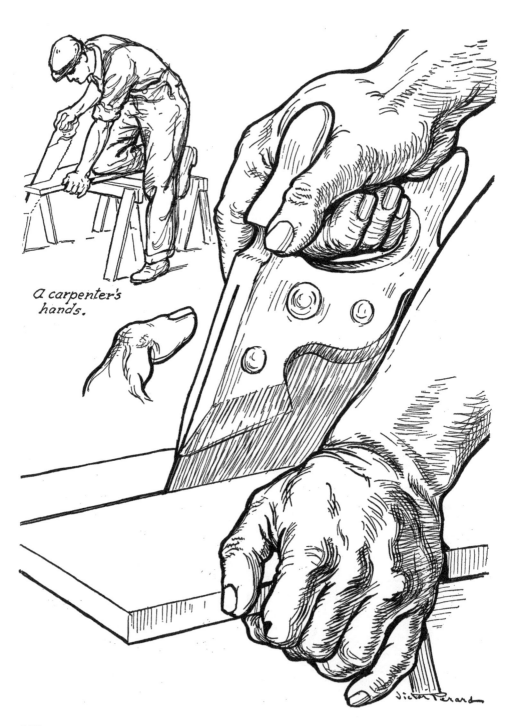

A carpenter's
hands.

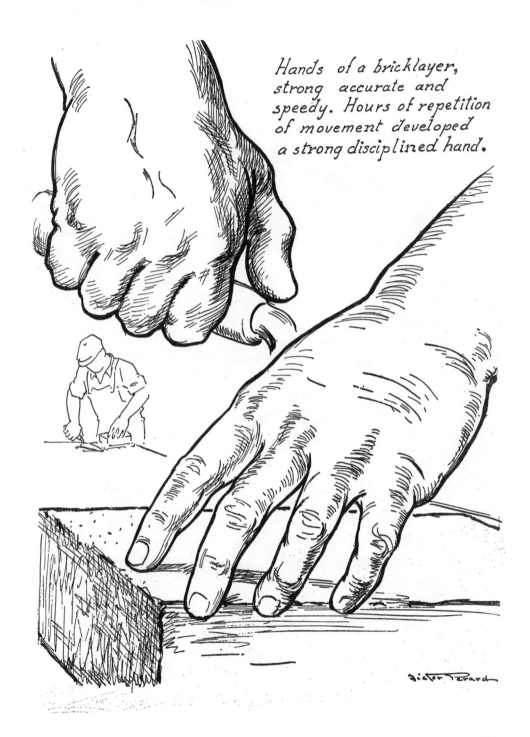

Hands of a bricklayer, strong accurate and speedy. Hours of repetition of movement developed a strong disciplined hand.

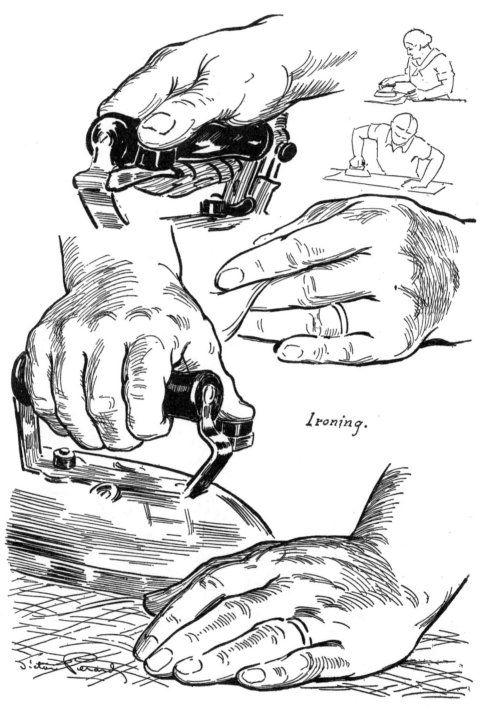

Ironing.

160

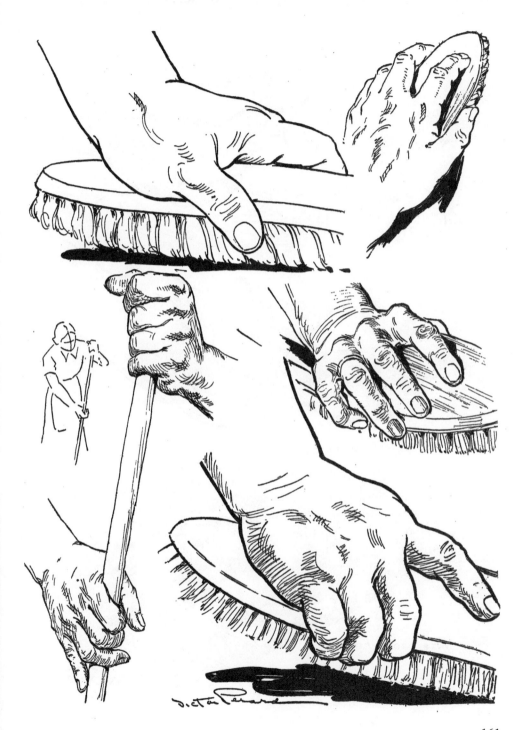

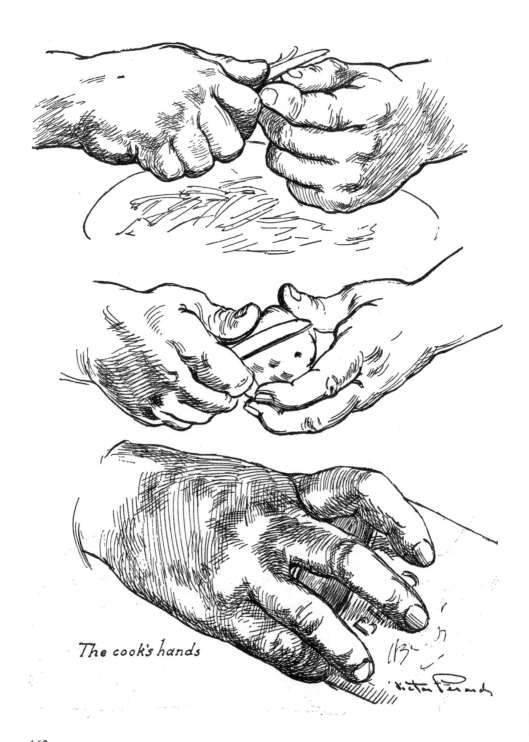

The cook's hands

162

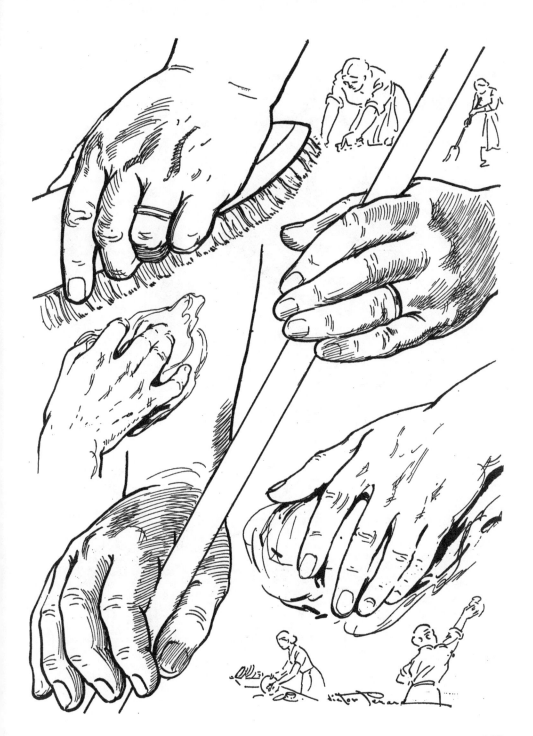

163

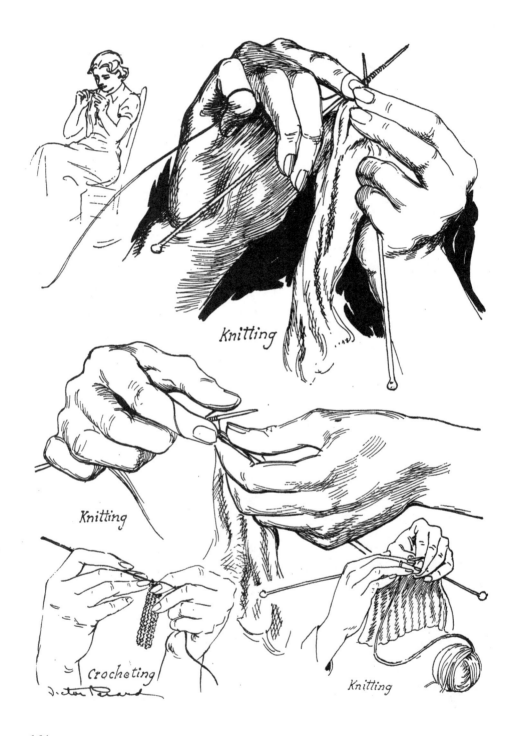

Knitting

Knitting

Crocheting

Knitting

164

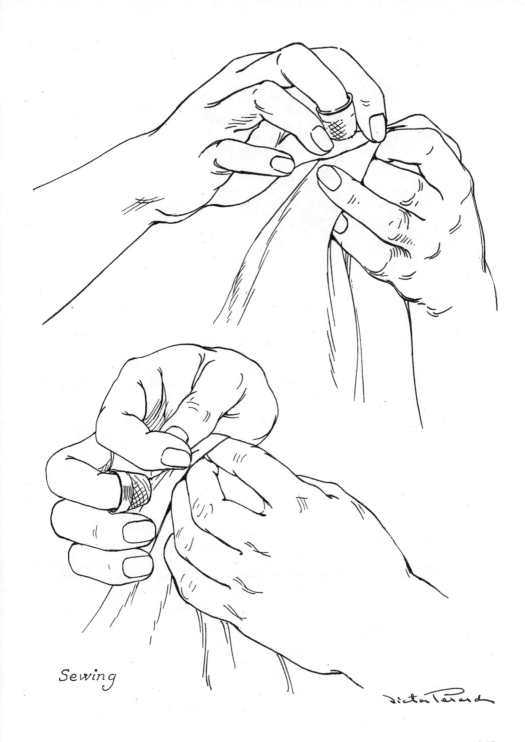

Sewing

165

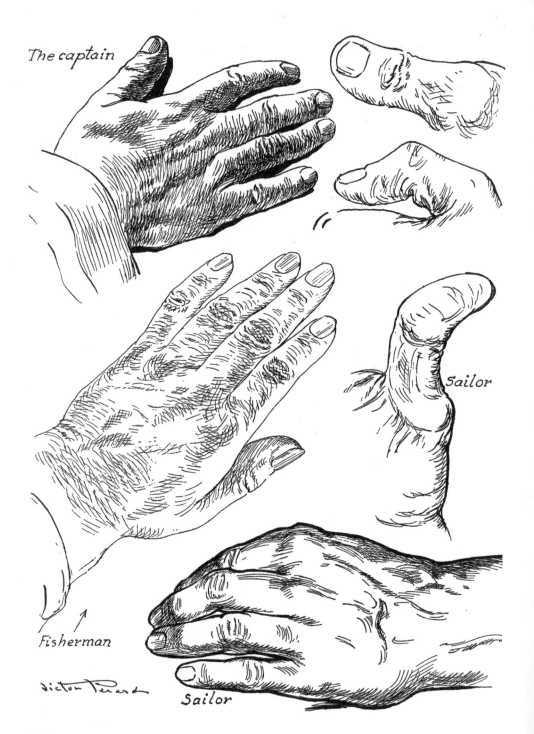

The captain

Sailor

Fisherman

Sailor

Victor Perard

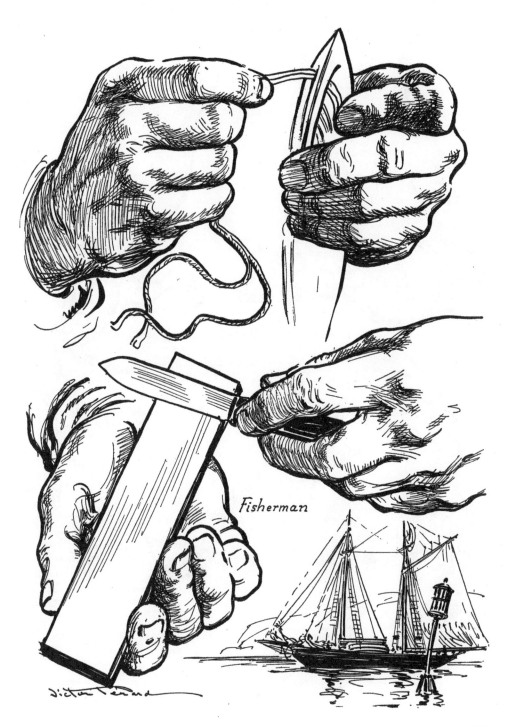

Fisherman

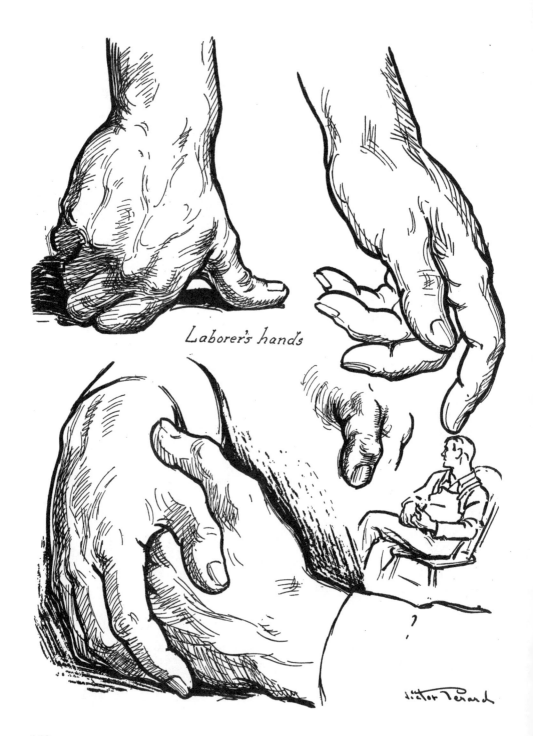

Laborer's hands

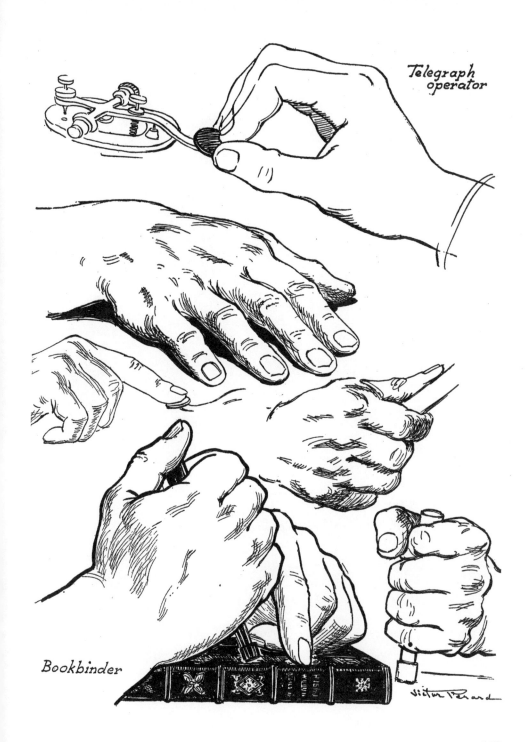

Telegraph operator

Bookbinder

169

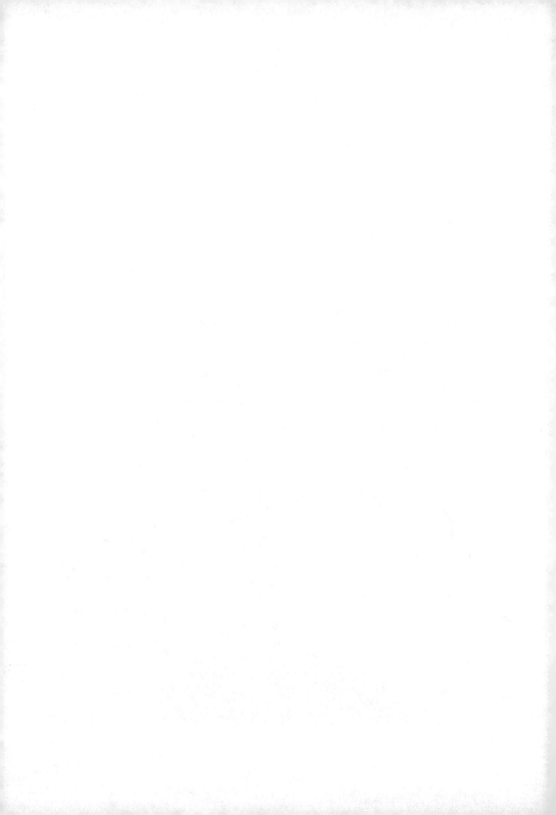

GROUP 8
HANDS of ELDERLY PEOPLE

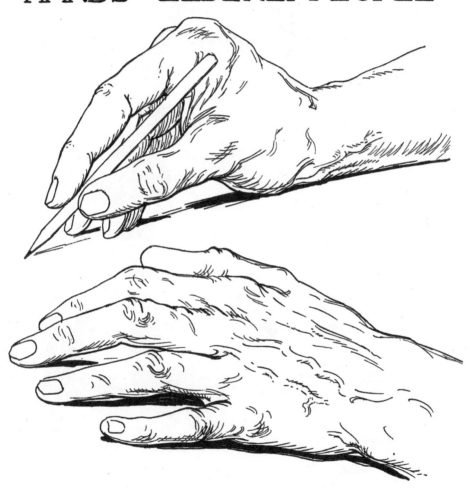

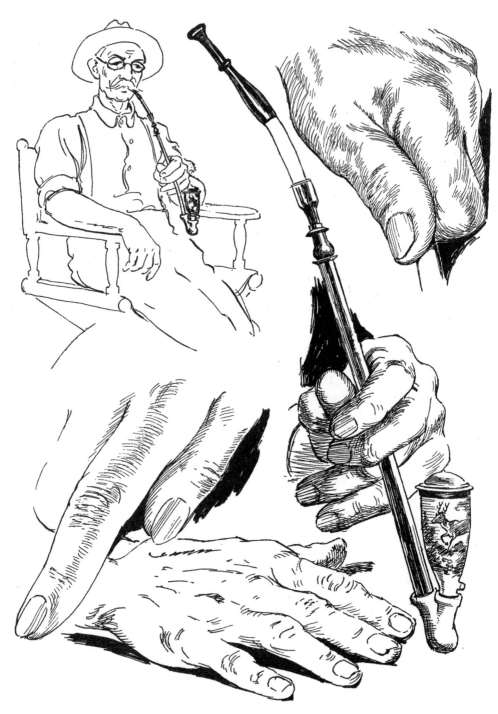

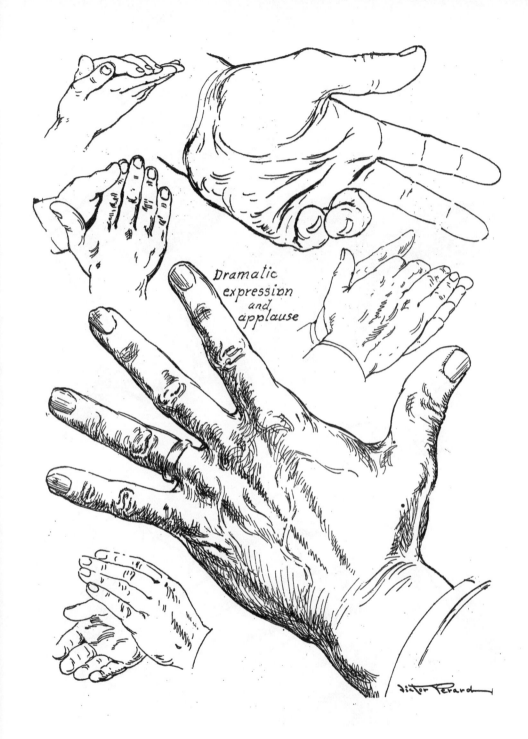

Dramatic
expression
and
applause

173

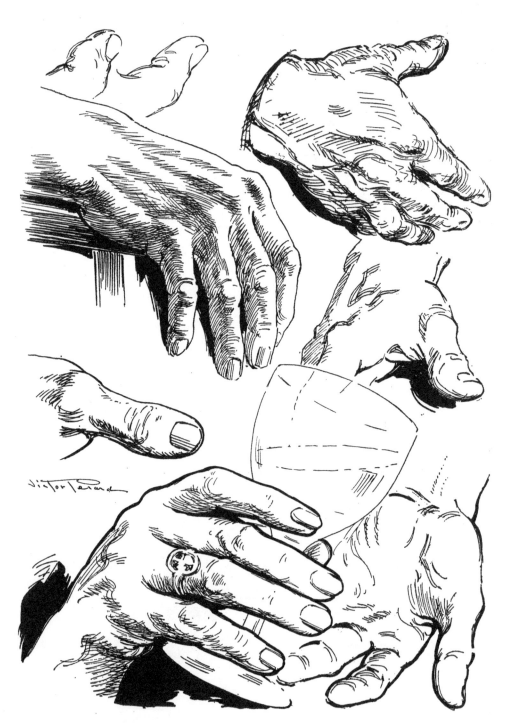

174

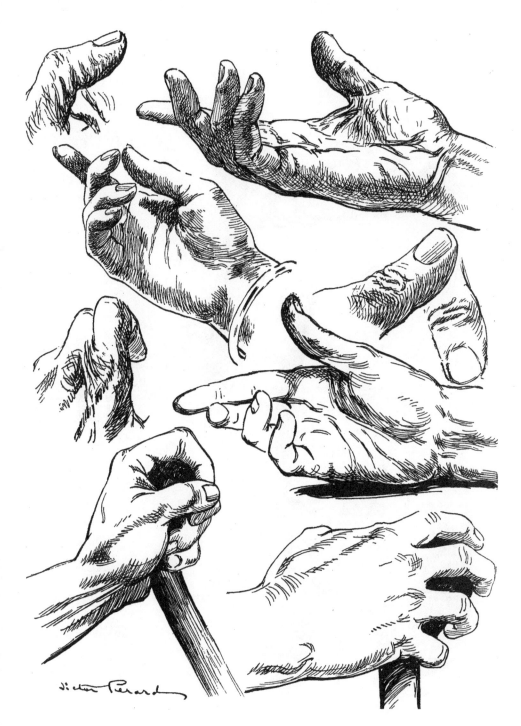

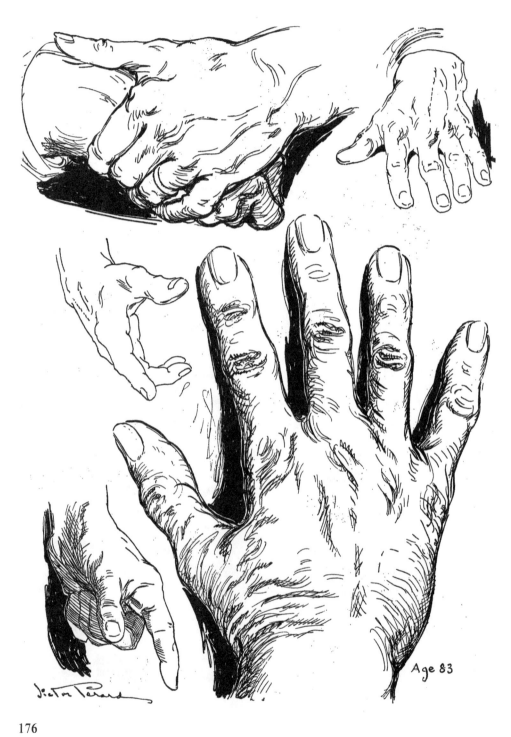

Age 83

176

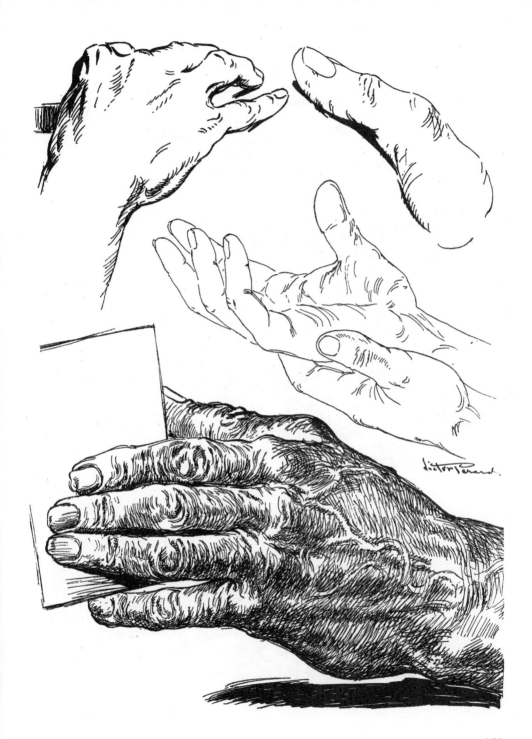

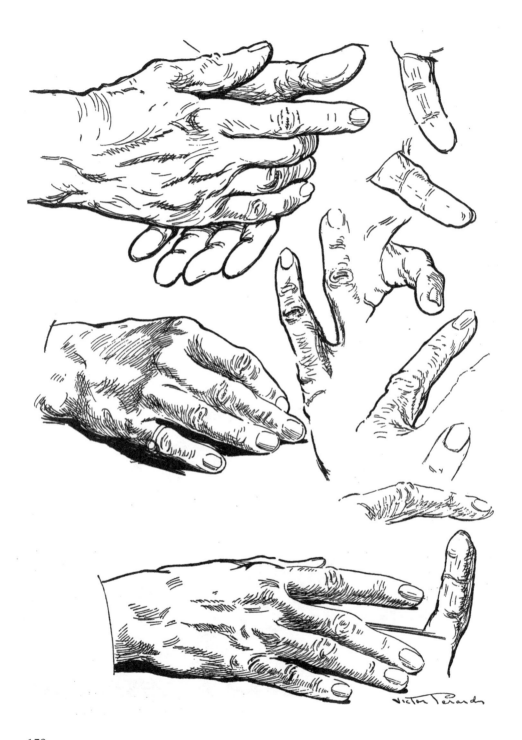

Victor Perard

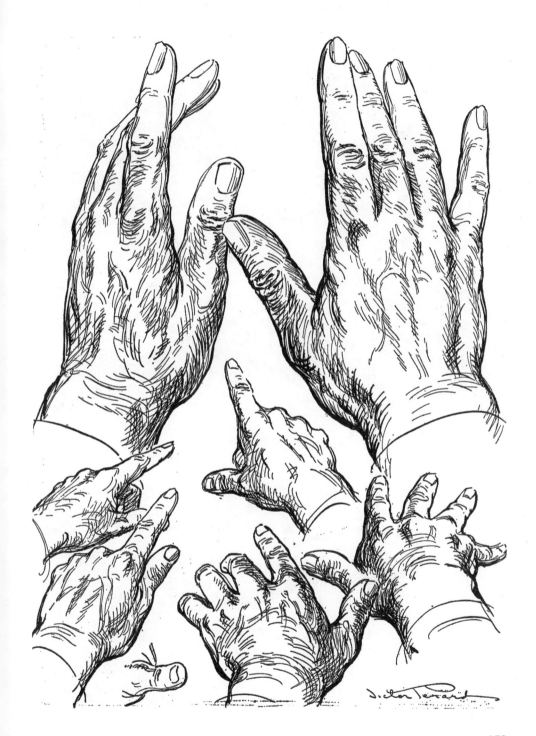

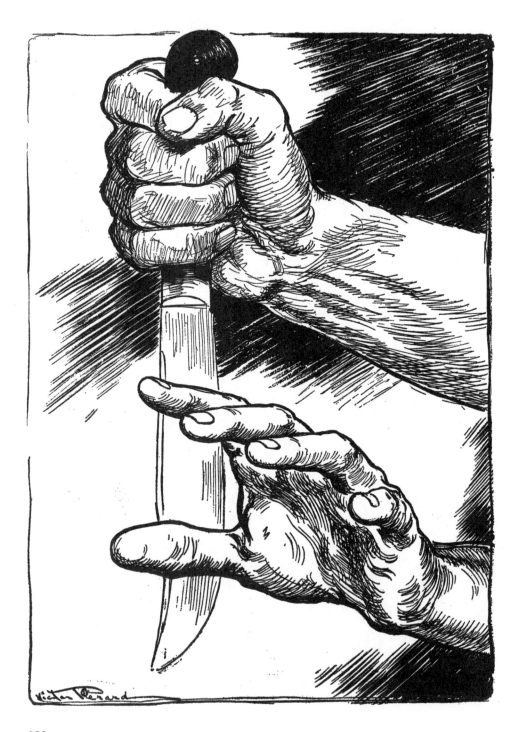

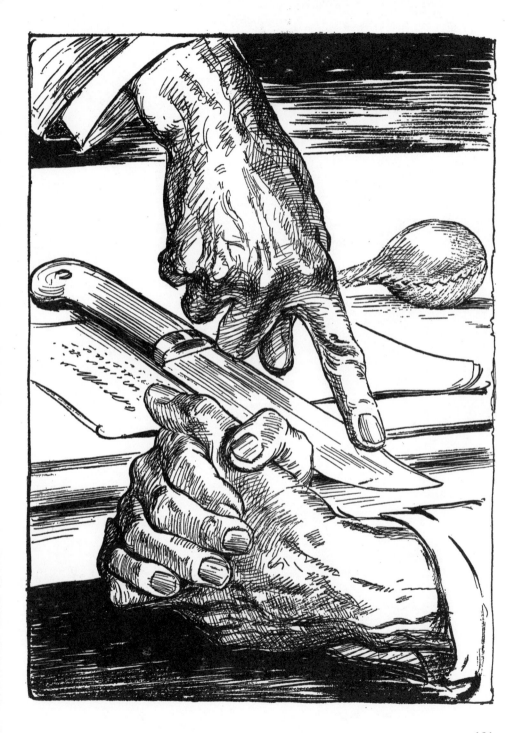

GROUP 9
BABIES' and CHILDREN'S HANDS

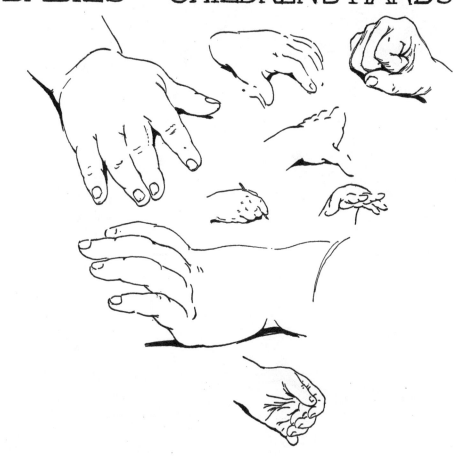

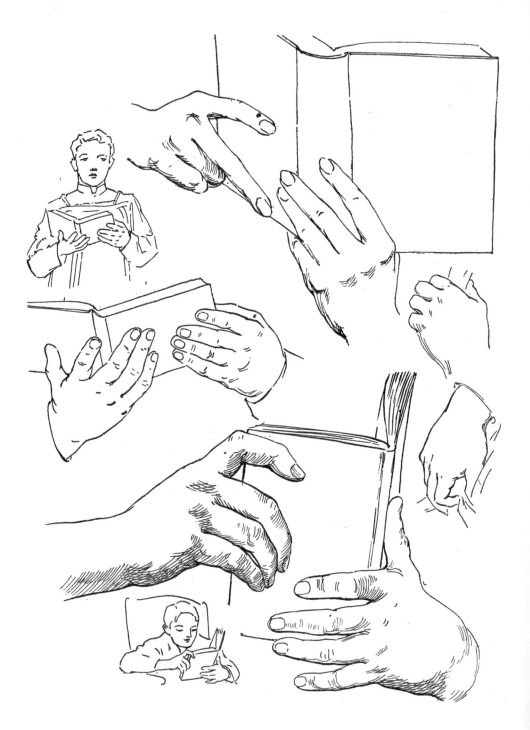

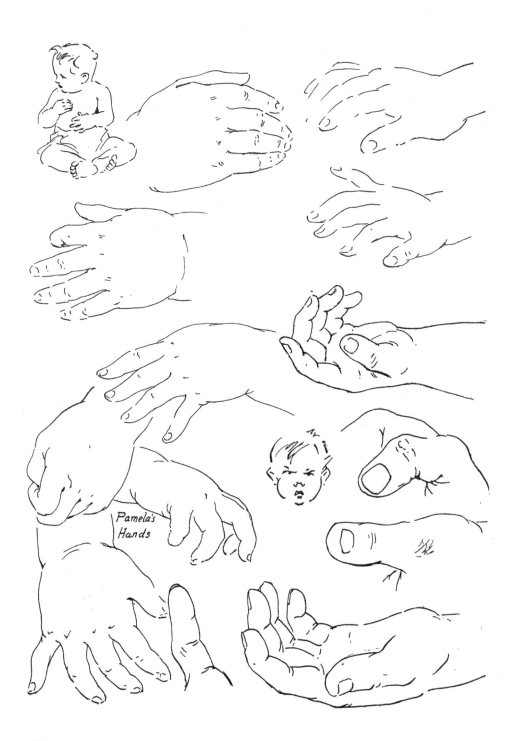

Pamela's
Hands

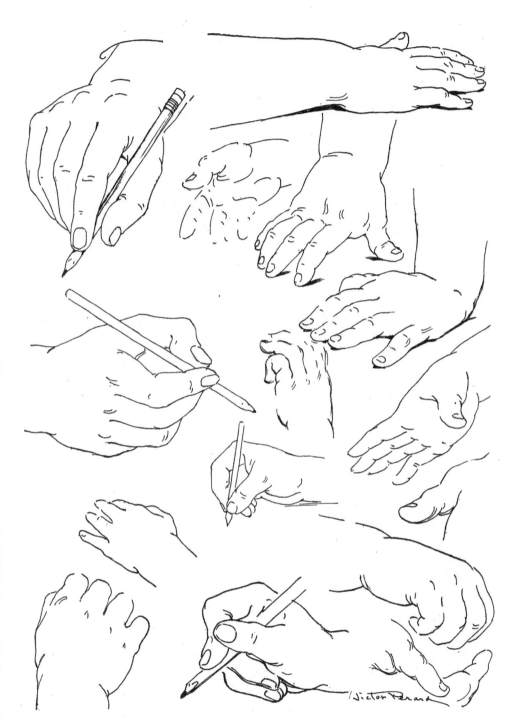

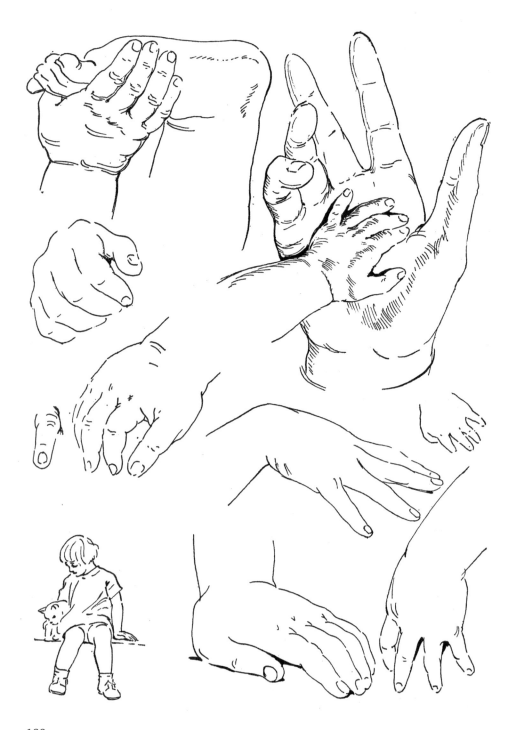

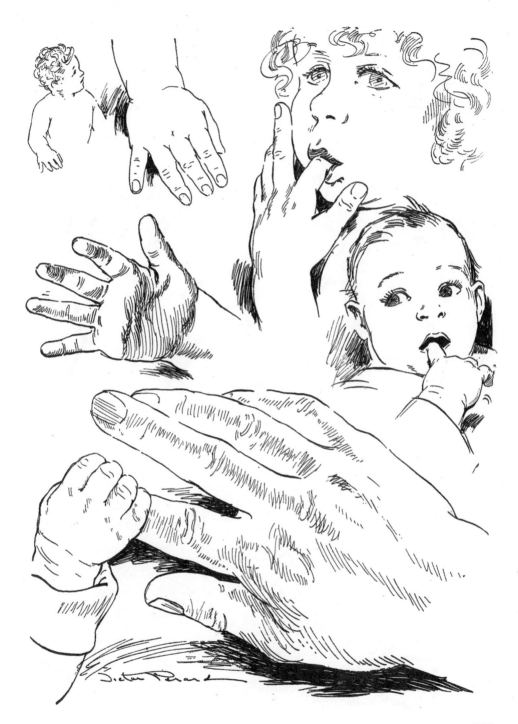

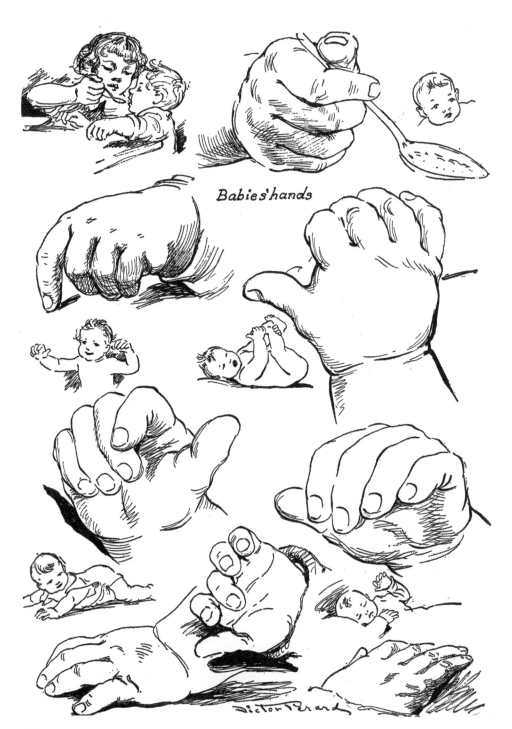

Babies' hands

Victor Perard

190

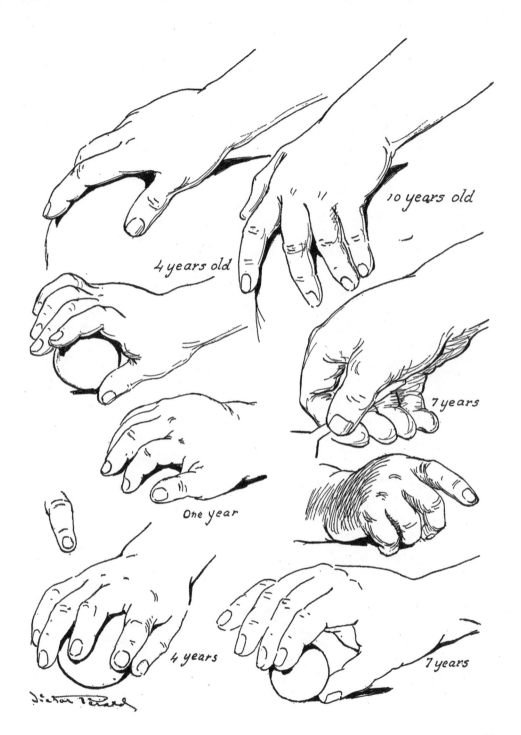

4 years old

10 years old

7 years

One year

4 years

7 years

191

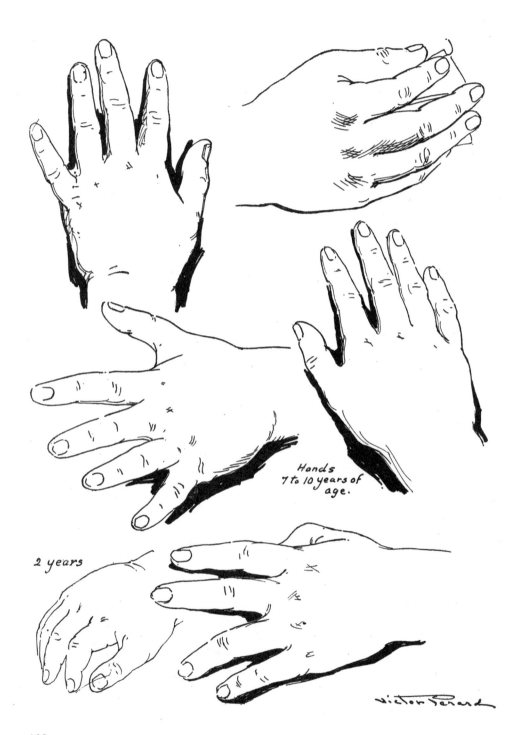

Hands
7 to 10 years of
age.

2 years

Victor Perard

192

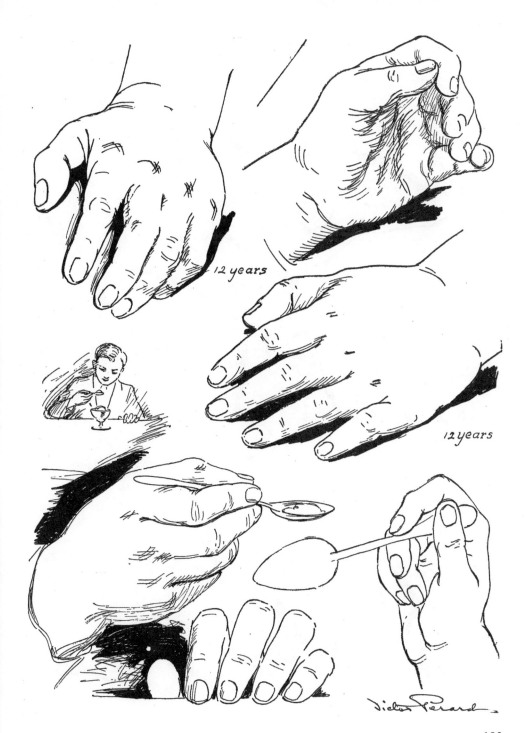

12 years

12 years

193

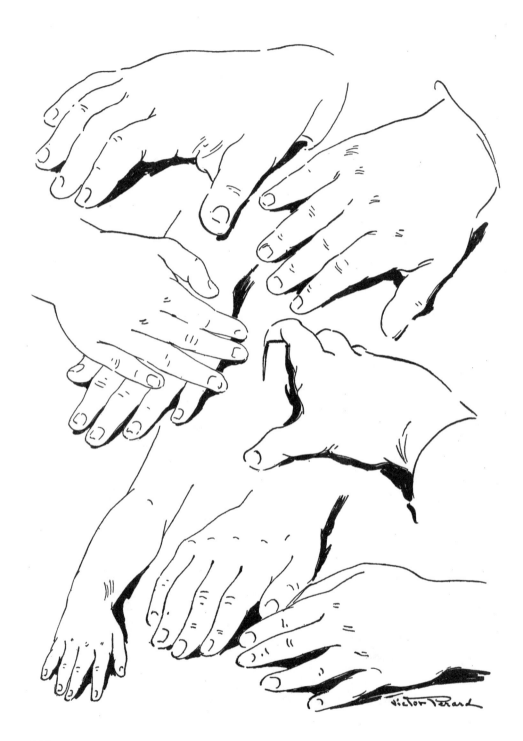

194

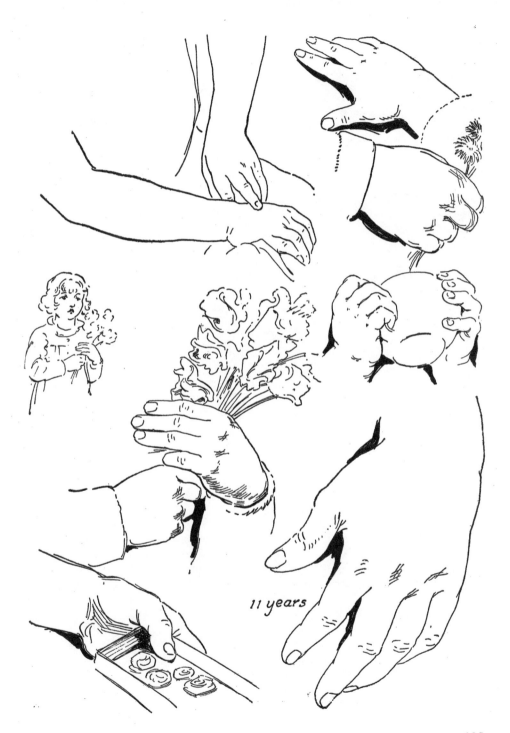

11 years

195

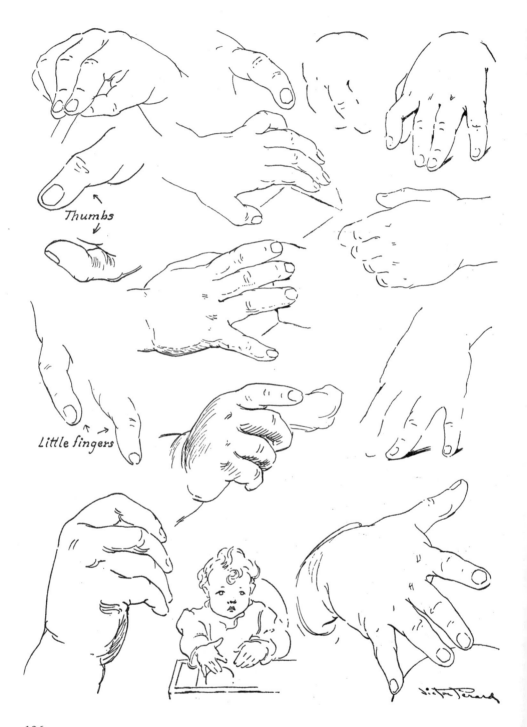

Thumbs

Little fingers

196

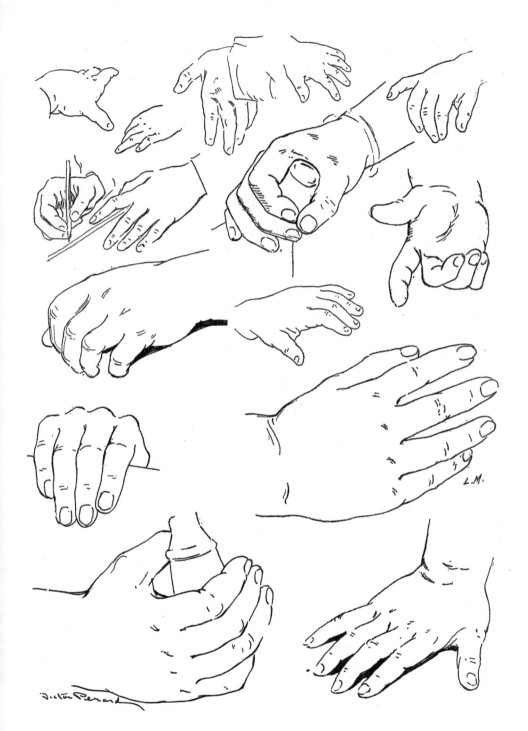

L.M.

GROUP 10
HANDS in GAMES and SPORTS

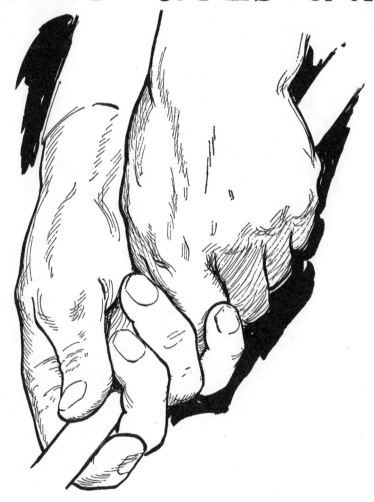

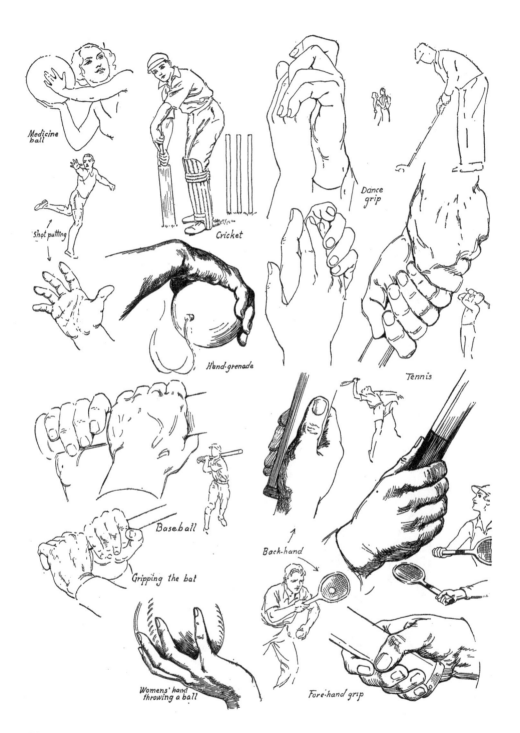

Medicine ball

Shot putting

Cricket

Hand-grenade

Dance grip

Tennis

Baseball

Gripping the bat

Back-hand

Fore-hand grip

Womens' hand throwing a ball

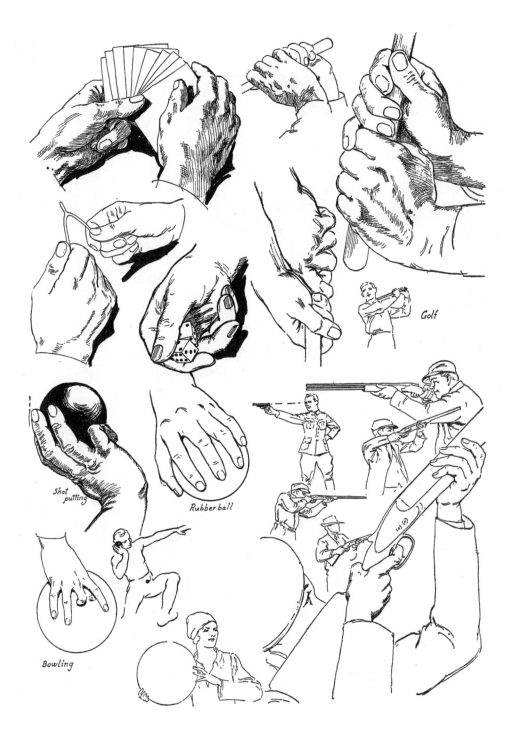

Golf

Shot
putting

Rubber ball

Bowling

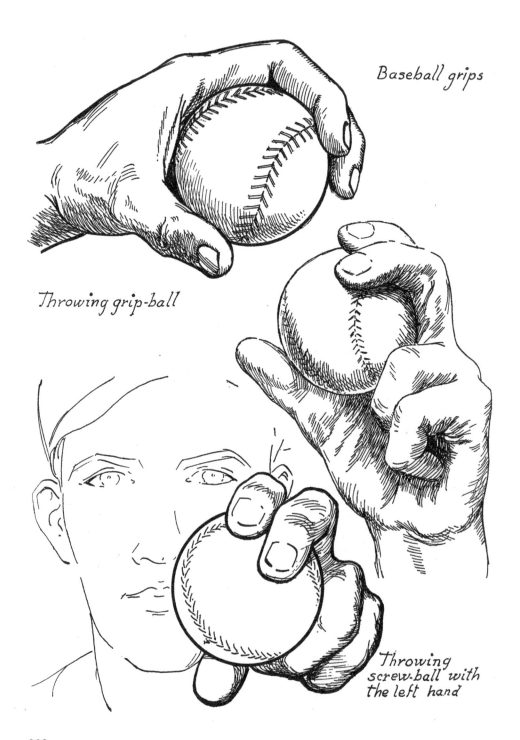

Baseball grips

Throwing grip-ball

Throwing
screw-ball with
the left hand

202

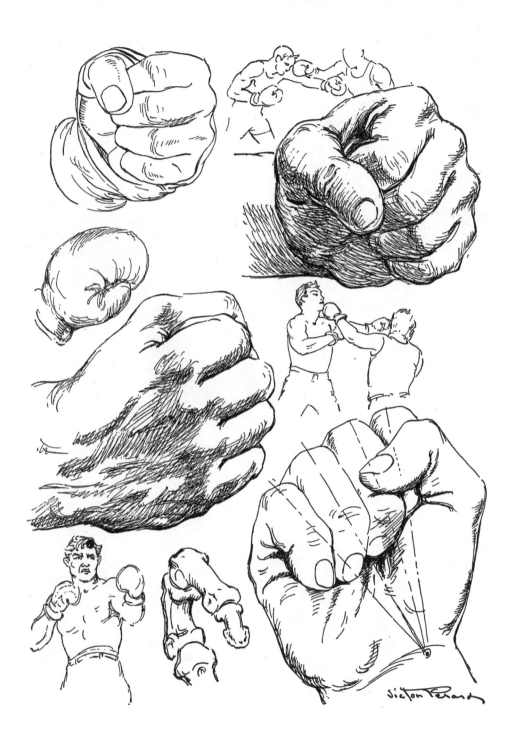

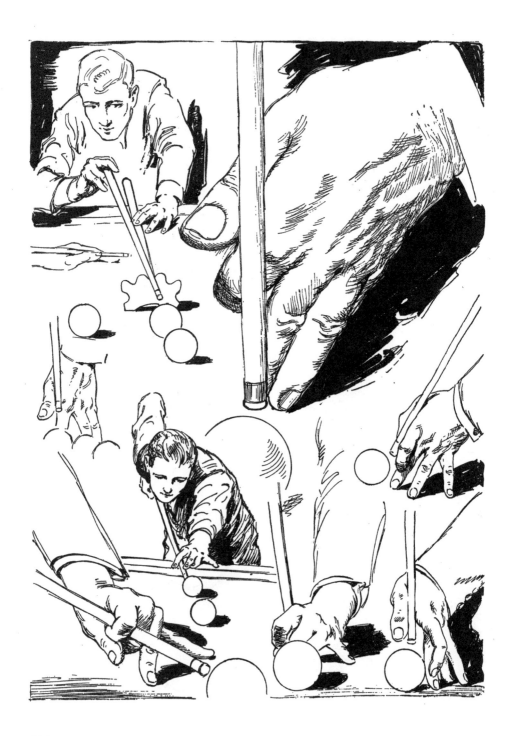

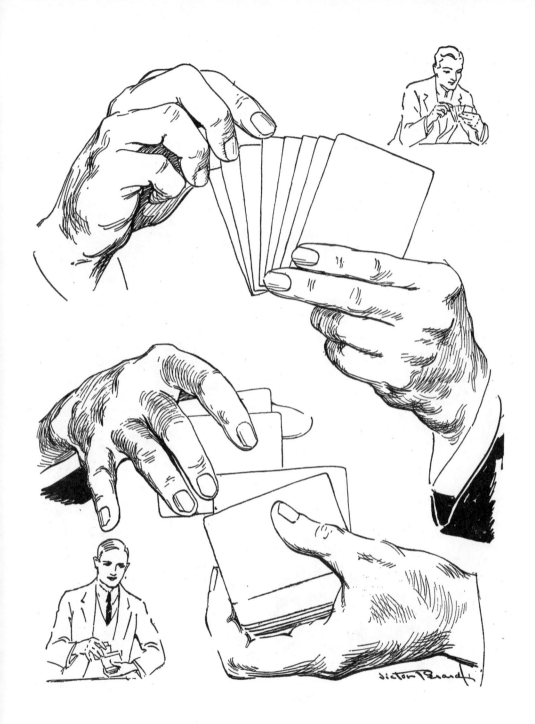

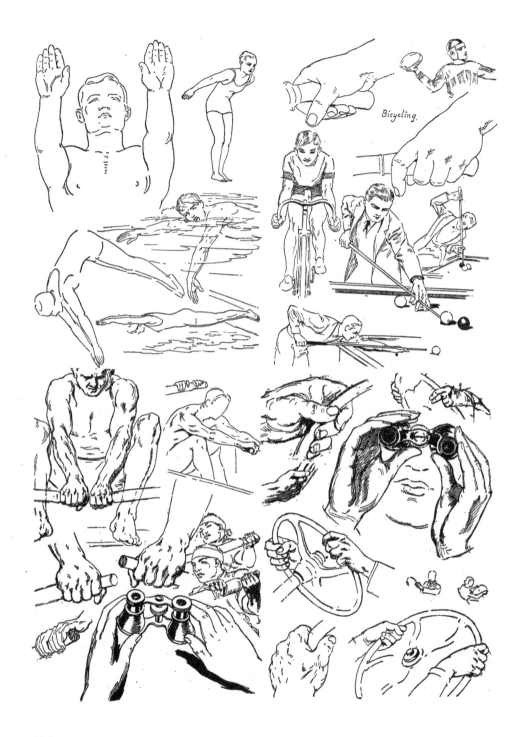

Bicycling.



206

A CATALOG OF SELECTED
DOVER BOOKS
IN ALL FIELDS OF INTEREST

A CATALOG OF SELECTED DOVER
BOOKS IN ALL FIELDS OF INTEREST

100 BEST-LOVED POEMS, Edited by Philip Smith. "The Passionate Shepherd to His Love," "Shall I compare thee to a summer's day?" "Death, be not proud," "The Raven," "The Road Not Taken," plus works by Blake, Wordsworth, Byron, Shelley, Keats, many others. 96pp. 5³⁄₁₆ x 8¼. 0-486-28553-7

100 SMALL HOUSES OF THE THIRTIES, Brown-Blodgett Company. Exterior photographs and floor plans for 100 charming structures. Illustrations of models accompanied by descriptions of interiors, color schemes, closet space, and other amenities. 200 illustrations. 112pp. 8⅜ x 11. 0-486-44131-8

1000 TURN-OF-THE-CENTURY HOUSES: With Illustrations and Floor Plans, Herbert C. Chivers. Reproduced from a rare edition, this showcase of homes ranges from cottages and bungalows to sprawling mansions. Each house is meticulously illustrated and accompanied by complete floor plans. 256pp. 9⅜ x 12¼.

0-486-45596-3

101 GREAT AMERICAN POEMS, Edited by The American Poetry & Literacy Project. Rich treasury of verse from the 19th and 20th centuries includes works by Edgar Allan Poe, Robert Frost, Walt Whitman, Langston Hughes, Emily Dickinson, T. S. Eliot, other notables. 96pp. 5³⁄₁₆ x 8¼. 0-486-40158-8

101 GREAT SAMURAI PRINTS, Utagawa Kuniyoshi. Kuniyoshi was a master of the warrior woodblock print — and these 18th-century illustrations represent the pinnacle of his craft. Full-color portraits of renowned Japanese samurais pulse with movement, passion, and remarkably fine detail. 112pp. 8⅜ x 11. 0-486-46523-3

ABC OF BALLET, Janet Grosser. Clearly worded, abundantly illustrated little guide defines basic ballet-related terms: arabesque, battement, pas de chat, relevé, sissonne, many others. Pronunciation guide included. Excellent primer. 48pp. 4³⁄₁₆ x 5¾.

0-486-40871-X

ACCESSORIES OF DRESS: An Illustrated Encyclopedia, Katherine Lester and Bess Viola Oerke. Illustrations of hats, veils, wigs, cravats, shawls, shoes, gloves, and other accessories enhance an engaging commentary that reveals the humor and charm of the many-sided story of accessorized apparel. 644 figures and 59 plates. 608pp. 6 ⅛ x 9¼.

0-486-43378-1

ADVENTURES OF HUCKLEBERRY FINN, Mark Twain. Join Huck and Jim as their boyhood adventures along the Mississippi River lead them into a world of excitement, danger, and self-discovery. Humorous narrative, lyrical descriptions of the Mississippi valley, and memorable characters. 224pp. 5³⁄₁₆ x 8¼. 0-486-28061-6

ALICE STARMORE'S BOOK OF FAIR ISLE KNITTING, Alice Starmore. A noted designer from the region of Scotland's Fair Isle explores the history and techniques of this distinctive, stranded-color knitting style and provides copious illustrated instructions for 14 original knitwear designs. 208pp. 8⅜ x 10⅞. 0-486-47218-3

CATALOG OF DOVER BOOKS

ALICE'S ADVENTURES IN WONDERLAND, Lewis Carroll. Beloved classic about a little girl lost in a topsy-turvy land and her encounters with the White Rabbit, March Hare, Mad Hatter, Cheshire Cat, and other delightfully improbable characters. 42 illustrations by Sir John Tenniel. 96pp. 5³⁄₁₆ x 8¼.　　　　0-486-27543-4

AMERICA'S LIGHTHOUSES: An Illustrated History, Francis Ross Holland. Profusely illustrated fact-filled survey of American lighthouses since 1716. Over 200 stations — East, Gulf, and West coasts, Great Lakes, Hawaii, Alaska, Puerto Rico, the Virgin Islands, and the Mississippi and St. Lawrence Rivers. 240pp. 8 x 10¾.
0-486-25576-X

AN ENCYCLOPEDIA OF THE VIOLIN, Alberto Bachmann. Translated by Frederick H. Martens. Introduction by Eugene Ysaye. First published in 1925, this renowned reference remains unsurpassed as a source of essential information, from construction and evolution to repertoire and technique. Includes a glossary and 73 illustrations. 496pp. 6½ x 9¼.　　　　0-486-46618-3

ANIMALS: 1,419 Copyright-Free Illustrations of Mammals, Birds, Fish, Insects, etc., Selected by Jim Harter. Selected for its visual impact and ease of use, this outstanding collection of wood engravings presents over 1,000 species of animals in extremely lifelike poses. Includes mammals, birds, reptiles, amphibians, fish, insects, and other invertebrates. 284pp. 9 x 12.　　　　0-486-23766-4

THE ANNALS, Tacitus. Translated by Alfred John Church and William Jackson Brodribb. This vital chronicle of Imperial Rome, written by the era's great historian, spans A.D. 14-68 and paints incisive psychological portraits of major figures, from Tiberius to Nero. 416pp. 5³⁄₁₆ x 8¼.　　　　0-486-45236-0

ANTIGONE, Sophocles. Filled with passionate speeches and sensitive probing of moral and philosophical issues, this powerful and often-performed Greek drama reveals the grim fate that befalls the children of Oedipus. Footnotes. 64pp. 5³⁄₁₆ x 8 ¼.　　　　0-486-27804-2

ART DECO DECORATIVE PATTERNS IN FULL COLOR, Christian Stoll. Reprinted from a rare 1910 portfolio, 160 sensuous and exotic images depict a breathtaking array of florals, geometrics, and abstracts — all elegant in their stark simplicity. 64pp. 8⅜ x 11.　　　　0-486-44862-2

THE ARTHUR RACKHAM TREASURY: 86 Full-Color Illustrations, Arthur Rackham. Selected and Edited by Jeff A. Menges. A stunning treasury of 86 full-page plates span the famed English artist's career, from *Rip Van Winkle* (1905) to masterworks such as *Undine, A Midsummer Night's Dream,* and *Wind in the Willows* (1939). 96pp. 8⅜ x 11.
0-486-44685-9

THE AUTHENTIC GILBERT & SULLIVAN SONGBOOK, W. S. Gilbert and A. S. Sullivan. The most comprehensive collection available, this songbook includes selections from every one of Gilbert and Sullivan's light operas. Ninety-two numbers are presented uncut and unedited, and in their original keys. 410pp. 9 x 12.
0-486-23482-7

THE AWAKENING, Kate Chopin. First published in 1899, this controversial novel of a New Orleans wife's search for love outside a stifling marriage shocked readers. Today, it remains a first-rate narrative with superb characterization. New introductory Note. 128pp. 5³⁄₁₆ x 8¼.　　　　0-486-27786-0

BASIC DRAWING, Louis Priscilla. Beginning with perspective, this commonsense manual progresses to the figure in movement, light and shade, anatomy, drapery, composition, trees and landscape, and outdoor sketching. Black-and-white illustrations throughout. 128pp. 8⅜ x 11.　　　　0-486-45815-6

Browse over 9,000 books at www.doverpublications.com

THE BATTLES THAT CHANGED HISTORY, Fletcher Pratt. Historian profiles 16 crucial conflicts, ancient to modern, that changed the course of Western civilization. Gripping accounts of battles led by Alexander the Great, Joan of Arc, Ulysses S. Grant, other commanders. 27 maps. 352pp. 5⅜ x 8½. 0-486-41129-X

BEETHOVEN'S LETTERS, Ludwig van Beethoven. Edited by Dr. A. C. Kalischer. Features 457 letters to fellow musicians, friends, greats, patrons, and literary men. Reveals musical thoughts, quirks of personality, insights, and daily events. Includes 15 plates. 410pp. 5⅜ x 8½. 0-486-22769-3

BERNICE BOBS HER HAIR AND OTHER STORIES, F. Scott Fitzgerald. This brilliant anthology includes 6 of Fitzgerald's most popular stories: "The Diamond as Big as the Ritz," the title tale, "The Offshore Pirate," "The Ice Palace," "The Jelly Bean," and "May Day." 176pp. 5⅜ x 8½. 0-486-47049-0

BESLER'S BOOK OF FLOWERS AND PLANTS: 73 Full-Color Plates from Hortus Eystettensis, 1613, Basilius Besler. Here is a selection of magnificent plates from the *Hortus Eystettensis,* which vividly illustrated and identified the plants, flowers, and trees that thrived in the legendary German garden at Eichstätt. 80pp. 8⅜ x 11. 0-486-46005-3

THE BOOK OF KELLS, Edited by Blanche Cirker. Painstakingly reproduced from a rare facsimile edition, this volume contains full-page decorations, portraits, illustrations, plus a sampling of textual leaves with exquisite calligraphy and ornamentation. 32 full-color illustrations. 32pp. 9⅜ x 12¼. 0-486-24345-1

THE BOOK OF THE CROSSBOW: With an Additional Section on Catapults and Other Siege Engines, Ralph Payne-Gallwey. Fascinating study traces history and use of crossbow as military and sporting weapon, from Middle Ages to modern times. Also covers related weapons: balistas, catapults, Turkish bows, more. Over 240 illustrations. 400pp. 7¼ x 10⅛. 0-486-28720-3

THE BUNGALOW BOOK: Floor Plans and Photos of 112 Houses, 1910, Henry L. Wilson. Here are 112 of the most popular and economic blueprints of the early 20th century — plus an illustration or photograph of each completed house. A wonderful time capsule that still offers a wealth of valuable insights. 160pp. 8⅜ x 11. 0-486-45104-6

THE CALL OF THE WILD, Jack London. A classic novel of adventure, drawn from London's own experiences as a Klondike adventurer, relating the story of a heroic dog caught in the brutal life of the Alaska Gold Rush. Note. 64pp. 5³⁄₁₆ x 8¼. 0-486-26472-6

CANDIDE, Voltaire. Edited by Francois-Marie Arouet. One of the world's great satires since its first publication in 1759. Witty, caustic skewering of romance, science, philosophy, religion, government — nearly all human ideals and institutions. 112pp. 5³⁄₁₆ x 8¼. 0-486-26689-3

CELEBRATED IN THEIR TIME: Photographic Portraits from the George Grantham Bain Collection, Edited by Amy Pastan. With an Introduction by Michael Carlebach. Remarkable portrait gallery features 112 rare images of Albert Einstein, Charlie Chaplin, the Wright Brothers, Henry Ford, and other luminaries from the worlds of politics, art, entertainment, and industry. 128pp. 8⅜ x 11. 0-486-46754-6

CHARIOTS FOR APOLLO: The NASA History of Manned Lunar Spacecraft to 1969, Courtney G. Brooks, James M. Grimwood, and Loyd S. Swenson, Jr. This illustrated history by a trio of experts is the definitive reference on the Apollo spacecraft and lunar modules. It traces the vehicles' design, development, and operation in space. More than 100 photographs and illustrations. 576pp. 6¾ x 9¼. 0-486-46756-2

A CHRISTMAS CAROL, Charles Dickens. This engrossing tale relates Ebenezer Scrooge's ghostly journeys through Christmases past, present, and future and his ultimate transformation from a harsh and grasping old miser to a charitable and compassionate human being. 80pp. 5⅜₆ x 8¼. 0-486-26865-9

COMMON SENSE, Thomas Paine. First published in January of 1776, this highly influential landmark document clearly and persuasively argued for American separation from Great Britain and paved the way for the Declaration of Independence. 64pp. 5⅜₆ x 8¼. 0-486-29602-4

THE COMPLETE SHORT STORIES OF OSCAR WILDE, Oscar Wilde. Complete texts of "The Happy Prince and Other Tales," "A House of Pomegranates," "Lord Arthur Savile's Crime and Other Stories," "Poems in Prose," and "The Portrait of Mr. W. H." 208pp. 5⅜₆ x 8¼. 0-486-45216-6

COMPLETE SONNETS, William Shakespeare. Over 150 exquisite poems deal with love, friendship, the tyranny of time, beauty's evanescence, death, and other themes in language of remarkable power, precision, and beauty. Glossary of archaic terms. 80pp. 5⅜₆ x 8¼. 0-486-26686-9

THE COUNT OF MONTE CRISTO: Abridged Edition, Alexandre Dumas. Falsely accused of treason, Edmond Dantès is imprisoned in the bleak Chateau d'If. After a hair-raising escape, he launches an elaborate plot to extract a bitter revenge against those who betrayed him. 448pp. 5⅜₆ x 8¼. 0-486-45643-9

CRAFTSMAN BUNGALOWS: Designs from the Pacific Northwest, Yoho & Merritt. This reprint of a rare catalog, showcasing the charming simplicity and cozy style of Craftsman bungalows, is filled with photos of completed homes, plus floor plans and estimated costs. An indispensable resource for architects, historians, and illustrators. 112pp. 10 x 7. 0-486-46875-5

CRAFTSMAN BUNGALOWS: 59 Homes from "The Craftsman," Edited by Gustav Stickley. Best and most attractive designs from Arts and Crafts Movement publication — 1903–1916 — includes sketches, photographs of homes, floor plans, descriptive text. 128pp. 8¼ x 11. 0-486-25829-7

CRIME AND PUNISHMENT, Fyodor Dostoyevsky. Translated by Constance Garnett. Supreme masterpiece tells the story of Raskolnikov, a student tormented by his own thoughts after he murders an old woman. Overwhelmed by guilt and terror, he confesses and goes to prison. 480pp. 5⅜₆ x 8¼. 0-486-41587-2

THE DECLARATION OF INDEPENDENCE AND OTHER GREAT DOCUMENTS OF AMERICAN HISTORY: 1775-1865, Edited by John Grafton. Thirteen compelling and influential documents: Henry's "Give Me Liberty or Give Me Death," Declaration of Independence, The Constitution, Washington's First Inaugural Address, The Monroe Doctrine, The Emancipation Proclamation, Gettysburg Address, more. 64pp. 5⅜₆ x 8¼. 0-486-41124-9

THE DESERT AND THE SOWN: Travels in Palestine and Syria, Gertrude Bell. "The female Lawrence of Arabia," Gertrude Bell wrote captivating, perceptive accounts of her travels in the Middle East. This intriguing narrative, accompanied by 160 photos, traces her 1905 sojourn in Lebanon, Syria, and Palestine. 368pp. 5⅜ x 8¼. 0-486-46876-3

A DOLL'S HOUSE, Henrik Ibsen. Ibsen's best-known play displays his genius for realistic prose drama. An expression of women's rights, the play climaxes when the central character, Nora, rejects a smothering marriage and life in "a doll's house." 80pp. 5⅜₆ x 8¼. 0-486-27062-9

DOOMED SHIPS: Great Ocean Liner Disasters, William H. Miller, Jr. Nearly 200 photographs, many from private collections, highlight tales of some of the vessels whose pleasure cruises ended in catastrophe: the *Morro Castle, Normandie, Andrea Doria, Europa,* and many others. 128pp. 8⅞ x 11¾.　　　　0-486-45366-9

THE DORÉ BIBLE ILLUSTRATIONS, Gustave Doré. Detailed plates from the Bible: the Creation scenes, Adam and Eve, horrifying visions of the Flood, the battle sequences with their monumental crowds, depictions of the life of Jesus, 241 plates in all. 241pp. 9 x 12.　　　　0-486-23004-X

DRAWING DRAPERY FROM HEAD TO TOE, Cliff Young. Expert guidance on how to draw shirts, pants, skirts, gloves, hats, and coats on the human figure, including folds in relation to the body, pull and crush, action folds, creases, more. Over 200 drawings. 48pp. 8¼ x 11.　　　　0-486-45591-2

DUBLINERS, James Joyce. A fine and accessible introduction to the work of one of the 20th century's most influential writers, this collection features 15 tales, including a masterpiece of the short-story genre, "The Dead." 160pp. 5³⁄₁₆ x 8¼.

0-486-26870-5

EASY-TO-MAKE POP-UPS, Joan Irvine. Illustrated by Barbara Reid. Dozens of wonderful ideas for three-dimensional paper fun — from holiday greeting cards with moving parts to a pop-up menagerie. Easy-to-follow, illustrated instructions for more than 30 projects. 299 black-and-white illustrations. 96pp. 8⅜ x 11.

0-486-44622-0

EASY-TO-MAKE STORYBOOK DOLLS: A "Novel" Approach to Cloth Dollmaking, Sherralyn St. Clair. Favorite fictional characters come alive in this unique beginner's dollmaking guide. Includes patterns for Pollyanna, Dorothy from *The Wonderful Wizard of Oz,* Mary of *The Secret Garden,* plus easy-to-follow instructions, 263 black-and-white illustrations, and an 8-page color insert. 112pp. 8¼ x 11.　0-486-47360-0

EINSTEIN'S ESSAYS IN SCIENCE, Albert Einstein. Speeches and essays in accessible, everyday language profile influential physicists such as Niels Bohr and Isaac Newton. They also explore areas of physics to which the author made major contributions. 128pp. 5 x 8.　　　　0-486-47011-3

EL DORADO: Further Adventures of the Scarlet Pimpernel, Baroness Orczy. A popular sequel to *The Scarlet Pimpernel,* this suspenseful story recounts the Pimpernel's attempts to rescue the Dauphin from imprisonment during the French Revolution. An irresistible blend of intrigue, period detail, and vibrant characterizations. 352pp. 5³⁄₁₆ x 8¼.　　　　0-486-44026-5

ELEGANT SMALL HOMES OF THE TWENTIES: 99 Designs from a Competition, Chicago Tribune. Nearly 100 designs for five- and six-room houses feature New England and Southern colonials, Normandy cottages, stately Italianate dwellings, and other fascinating snapshots of American domestic architecture of the 1920s. 112pp. 9 x 12.　　　　0-486-46910-7

THE ELEMENTS OF STYLE: The Original Edition, William Strunk, Jr. This is the book that generations of writers have relied upon for timeless advice on grammar, diction, syntax, and other essentials. In concise terms, it identifies the principal requirements of proper style and common errors. 64pp. 5⅜ x 8¼.　0-486-44798-7

THE ELUSIVE PIMPERNEL, Baroness Orczy. Robespierre's revolutionaries find their wicked schemes thwarted by the heroic Pimpernel — Sir Percival Blakeney. In this thrilling sequel, Chauvelin devises a plot to eliminate the Pimpernel and his wife. 272pp. 5³⁄₁₆ x 8¼.　　　　0-486-45464-9